Color your worries away!

Be more relaxed, focused, and energized! Coloring helps you express *your personal creativity.* Find your own style in the pages that follow. Here are some ideas to

Color Theory 101

COLOR WHEEL

Complementary Colors
(Opposite on the color wheel)

Analogous Colors
(Sit next to each other on the color wheel)

RED
PRIMARY

RED-ORANGE
TERTIARY

ORANGE
SECONDARY

YELLOW-ORANGE
TERTIARY

YELLOW
PRIMARY

YELLOW-GREEN
TERTIARY

GREEN
SECONDARY

BLUE-GREEN
TERTIARY

BLUE
PRIMARY

BLUE-PURPLE
TERTIARY

PURPLE
SECONDARY

RED-PURPLE
TERTIARY

Warm Colors

Warm colors are vivid and energetic.

Cool Colors

Cool colors are calm and soothing.

Complementary Colors

Use complementary color when you want to emphasize the colors. They naturally play off one another and make each other look more vivid and intense.

Analogous Colors

Use analogous colors when you want more than one color but want to maintain a sense of unity.

Primary Colors

Primary colors can't be mixed or made. Different combinations of primary colors create all other traditional colors.

Secondary Colors

Combining two primary colors together creates a secondary color.

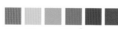

Tertiary Colors

Combining a primary and a secondary color results in a tertiary color. You may know them by their fancier names like "teal" or "lime green" but they are referred to by the two colors that make them up, with the primary color first.

art
UNPLUGGED

A NATURAL
SOURCE OF
HEALING

Stippling is filling in space with tiny dots—tightly packed, spread out, or however you want to place them. This can add texture and interest to your designs.

Hatching is filling space with a series of separate parallel lines.

Cross-hatching is drawing a layer of hatching and then adding a second layer of hatching in another direction, on top. It can give the illusion of depth and shading.

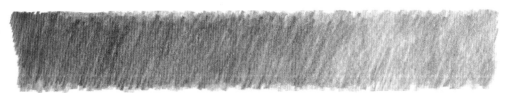

Back-and-forth stroke ("scribbling") is a simple continuous motion to fill in space with a solid color. Do it without lifting your pencil or marker off the page.

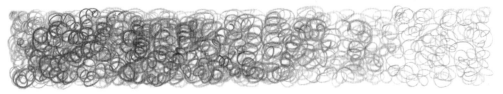

Circular stroke is another way to fill a space with solid color: moving your pencil or marker continuously in overlapping circles.

Tip: Keep Your Colors Safe

Store your colored pencils somewhere safe, where they won't be dropped or shuffled around. That will protect the lead inside your pencils and keep it from cracking, so your pencils sharpen cleanly and easily.

Adding Texture and Layers and Detail

Sharp colored pencils and fine markers are great for coloring delicate details.

You can add textures and depth by starting with a light color and then going back and coloring over it with a darker color, or pressing down harder with the same pencil or marker.

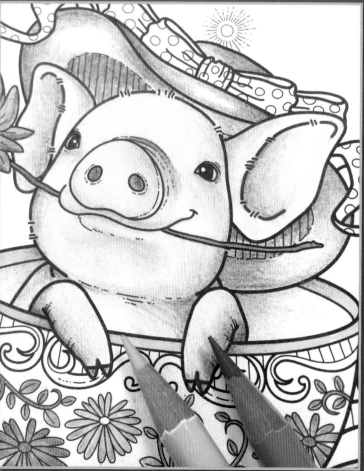

Different colors can be blended together in a smooth transition.

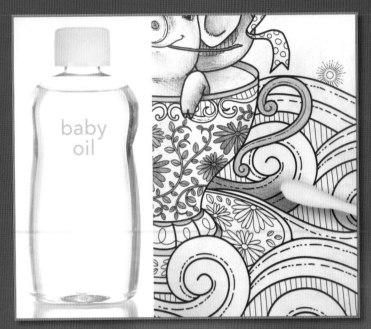

Use a cotton swab lightly dipped in baby oil to soften hard edges or smooth two blending colors together.

Add white highlights with a gel pen, or a fine brush with white paint, to look like light reflecting on a surface.

A NATURAL SOURCE OF HEALING

Puzzle Creations

VOLUME 2

art
UNPLUGGED

A NATURAL
SOURCE OF
HEALING

©2016 Art-Unplugged
3101 Clairmont Road · Suite G · Atlanta, GA 30329

Design by Dana Wedman

For helpful tips, examples, and inspiration, please visit: **art-unplugged.me**

This book is not intended as a substitute for the advice of a mental-health-care provider. The publisher encourages taking personal responsibility for your own mental, physical, and spiritual well-being.

Puzzles included in this book have been researched with due diligence and our best intentions, and we believe them to be accurate. Please send any queries or corrections to the address above.

Look for the entire series of art-unplugged journals.

ISBN: 1940899168 (Puzzle Creations Vol 2)

Printed in the United States of America

This EXPERIENCE belongs to:

Popular Flowers

ACROSS

6 Longer name for mums or chrysanths

8 Also the name of a 1999 American film starring Tom Cruise

9 Also known as "Narcissus" or "Hermione"

10 Strongly associated with Spring

11 Flower named after the character Hyacinthus in Greek mythology

12 Flower of love

13 Another name for the color purple

16 Also the name of Harry Potter's mother

DOWN

1 Orange flower that is also the name of a song by Nirvana

2 Also a common name for girls

3 Shares similar spelling with the word "Orca"

4 Also the name for an instant breakfast product

5 Produces delicious "seeds of the Sun"

7 Often used to flavor green tea

14 Also the name for the colored part of the eye

15 Light purple flower that is also the state flower of New Hampshire

Famous Cat Breeds

ACROSS

4 Breed of the sinister duo that sang in "The Lady and the Tramp"
6 Breed of Garfield
10 Breed named after the mountain range that contains Mount Everest
12 Breed named after the grassland region of Africa
13 Result if you combined the capital of Cuba with the color of chocolate
14 Mac Manc McManx
15 Would be Raggedy Ann's best friend
16 Breed named after the very cold tundra region of North Asia

DOWN

1 Former name of Mumbai, India
2 Name of Giovanni's cat in "Pokemon" and common Iranian language
3 The result if you omit a single letter from Harvey Birdman's surname
5 What we would call a Tyrannosaurus Rex that came from Cornwall
7 Jake in "The Cat from Outer Space"
8 Result if you combined the Island of Bali with Siamese
9 Dr. Evil's cat in "Austin Powers": Mr. Bigglesworth
11 Famous breed from Maine similar to a raccoon

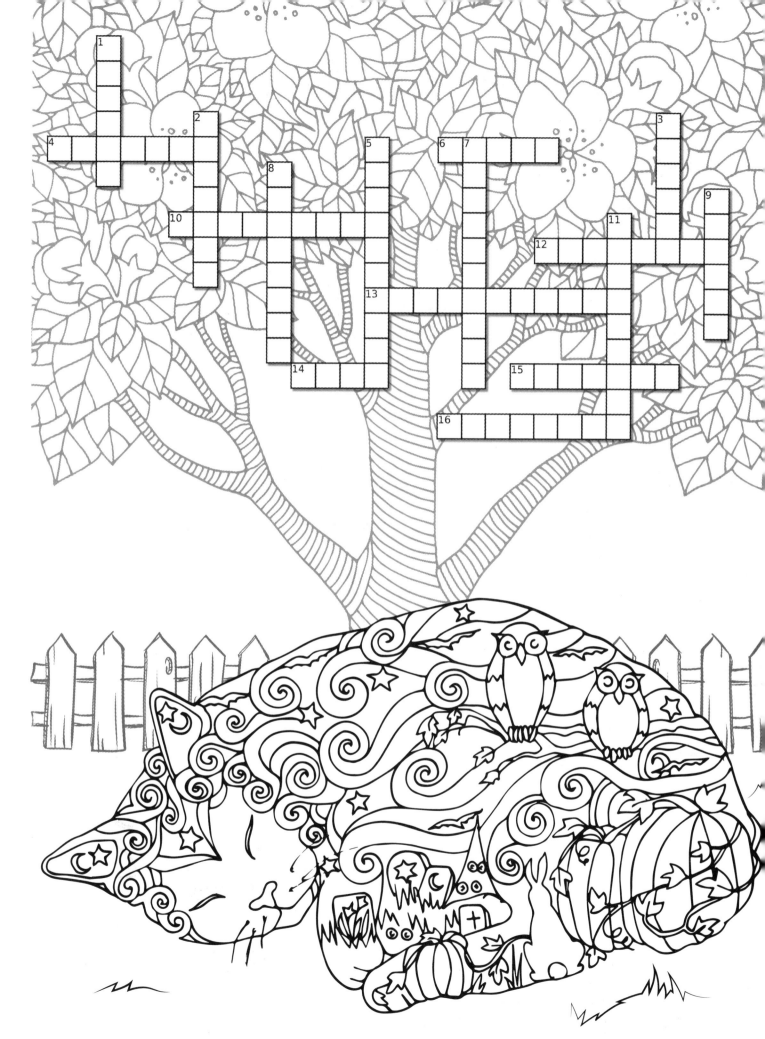

Music is the STRONGEST Form of Magic

ACROSS

4 "God's _____"

5 "_____ It Be"

8 "Somewhere Over the _____"

10 "_____ James Infirmary"

13 "_____ Song"

14 "_____ On Mars?"

15 "Strange _____"

16 "Sympathy for the _____"

DOWN

1 "Everybody _____"

2 "God Only _____"

3 "_____-Shaped Box"

6 "_____ Melody"

7 "I've Got You Under My _____"

9 "Dancing _____"

11 "_____ Up in Blue"

12 "_____ Criminal"

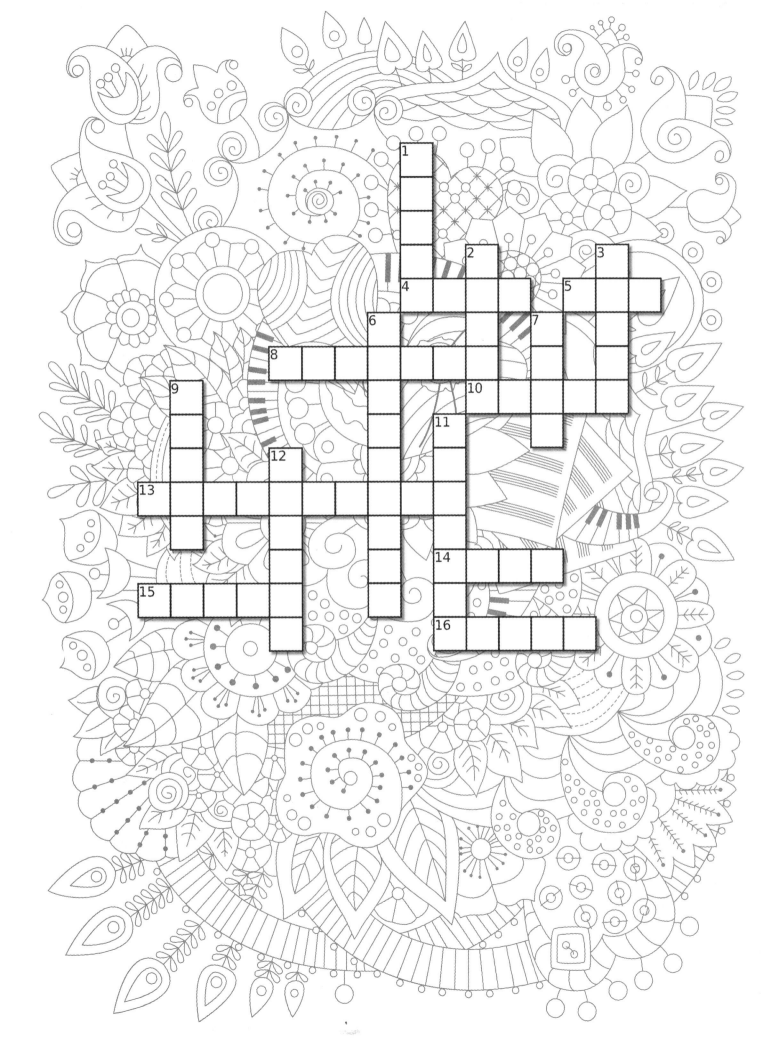

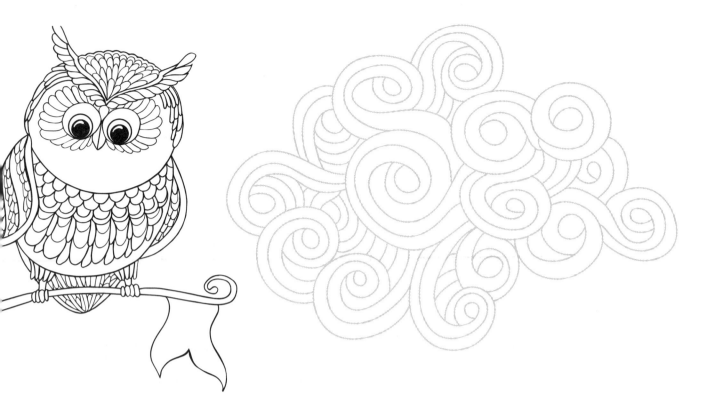

Woodland Critters

ACROSS

3 Known for building dams
6 "Strong as a _____"
7 Also known as a mountain lion
9 Jerry in the show "Tom and Jerry"
12 An energetic rodent that should never be given coffee
13 Always looks like it is wearing a mask
15 "ALVIN!!!"
16 Woody the _____

DOWN

1 Bambi
2 Sonic the _____
4 "Clever as a _____"
5 Bugs Bunny
8 Rodent covered in sharp spines
10 Pepe Le Pew
11 Red bird important to Catholics as well
14 Purdue _____

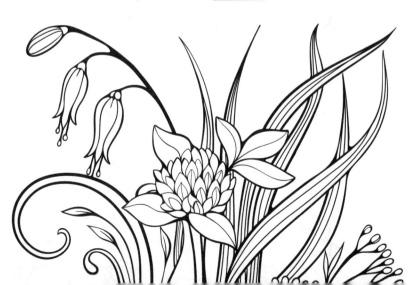

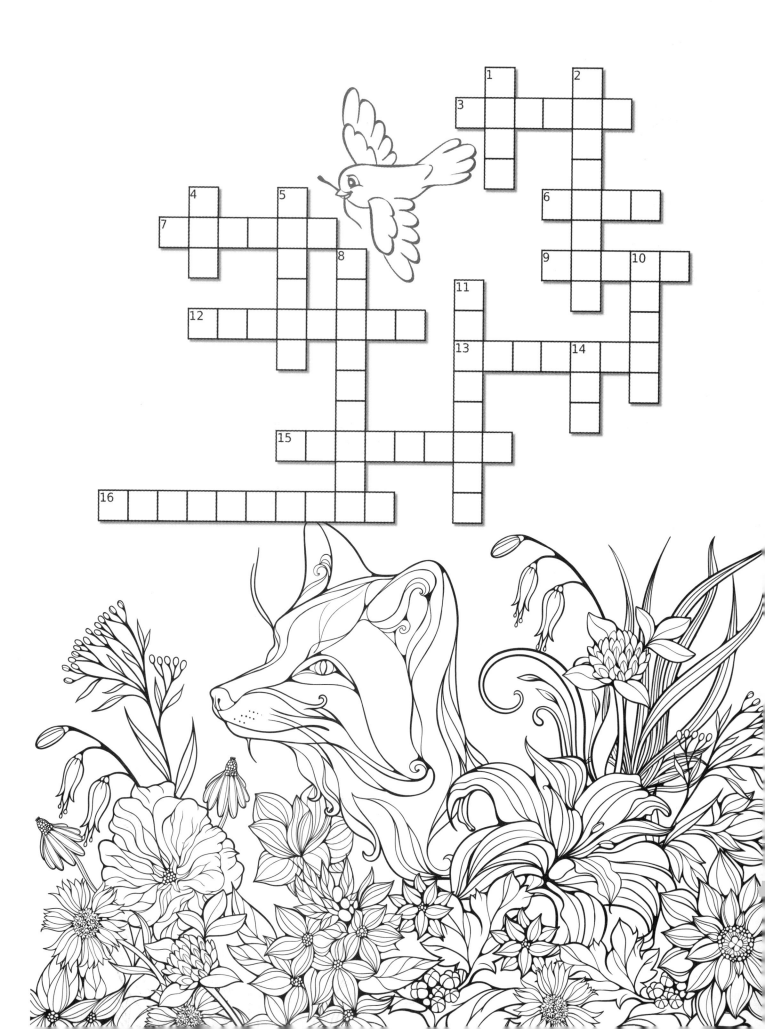

"Eat Your Veggies!"

ACROSS

3 Is technically a fruit
6 "Like a _____ in a pod"
7 Bugs Bunny is always seen with one
10 Also a satirical source of news
11 Vegetable used to make pickles
13 Root vegetable similar to both carrots and parsley
15 _____ Patch Kids
16 Goes great with parmesan

DOWN

1 Used to make French fries
2 Turn up
4 The main vegetable in most salads
5 Crunchy red salad vegetable
8 Squish _____
9 The vegetable that Popeye eats
12 Comes in florets
14 Potentially very hot vegetable of which ghost is a variety

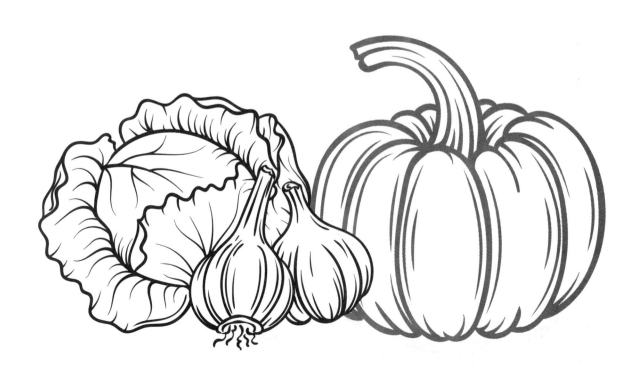

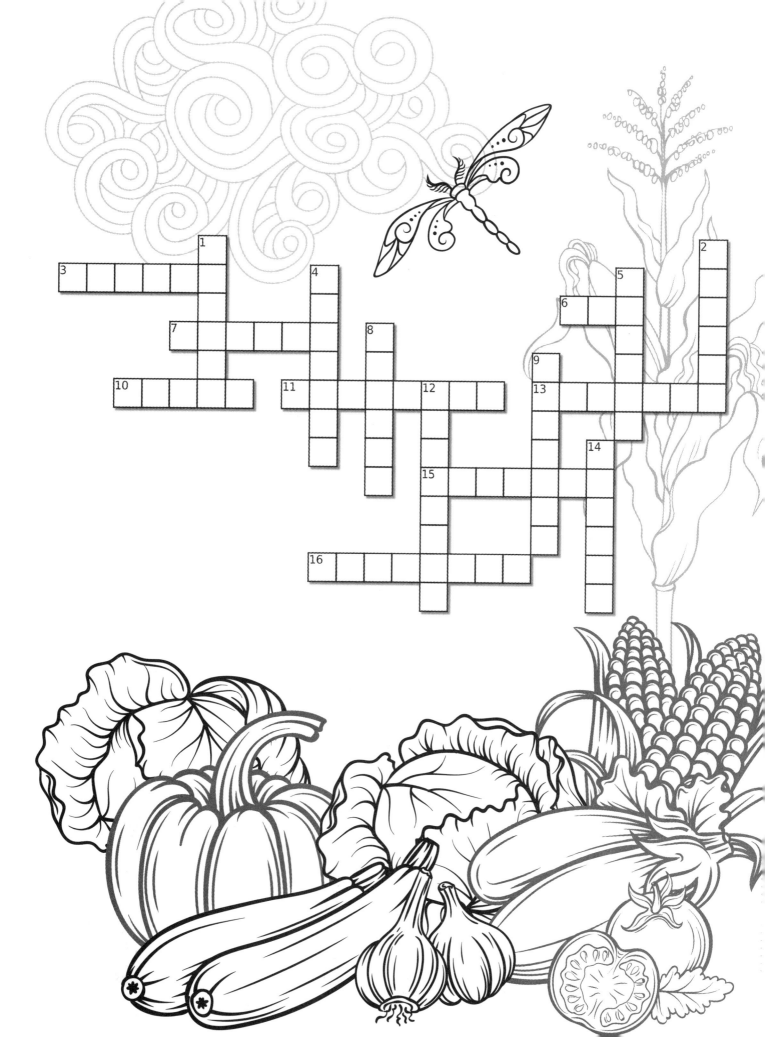

Life's a Beach... and then You Dive!

ACROSS

2 What sand turns into after being struck by lightning

5 Something surfers enjoy

9 Bird that will probably eat anything

10 Can be made into a castle

11 Two parts hydrogen, one part oxygen

13 Invertebrate that makes up reefs

14 A dollar in the sand

15 The envied result of sun exposure by those who burn

DOWN

1 Cancer the _____

3 Jaws

4 Type of trees on certain beaches

6 Patrick's species in "Spongebob Squarepants"

7 Sea plant that can be eaten

8 What happens when you use Crisco instead of sunscreen

9 Turtles that live a very long time

12 Something slimy that can sting you

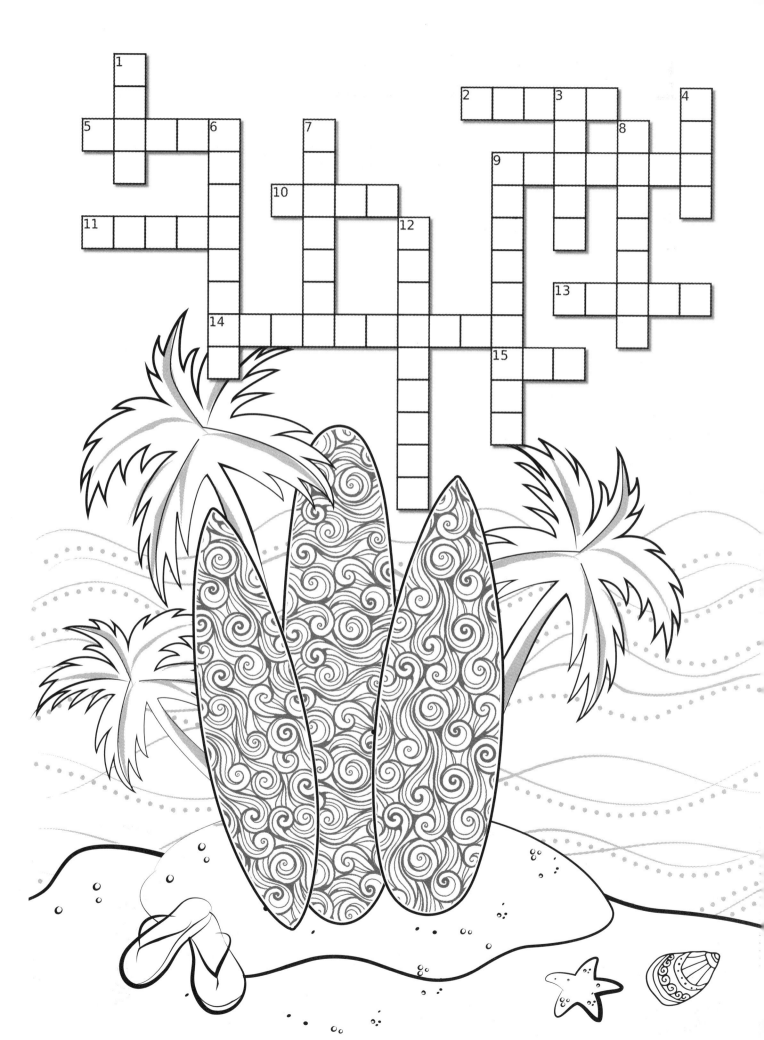

The Colors of the Rainbow... and More

ACROSS

3 The absence or complete absorption of light

4 Imperial color of the Holy Roman Empire

6 The result from combining every color of light

7 Result of mixing red and yellow

8 Common color for khaki pants

12 Also a common dye for blue jeans

13 A greenish-blue color

14 Associated with love and power

DOWN

1 "_____-belly"

2 "_____-eyed monster"

3 The color of the sky

5 Name of the best friend of Blue in "Blue's Clues"

8 The most common eye color in the world

9 Gandalf the _____

10 Also the name of a purple flower

11 Stage name of the American singer Alecia Beth Moore

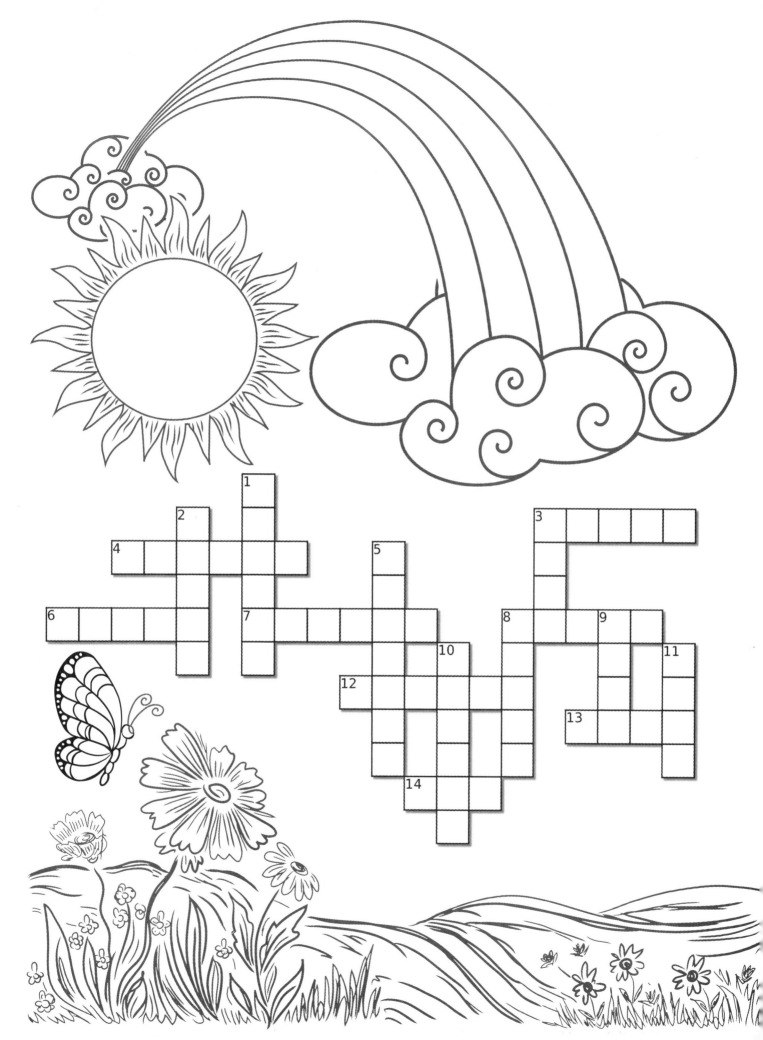

Complete that Movie Title!

ACROSS

4 The Lord of the Rings: The_____ of the Ring

8 Terminator 2: _____ Day

9 2001: A Space _____

10 Batman: The Dark _____

11 Pirates of the _____

13 West _____ Story

15 Silence of the _____

16 Jurassic _____

DOWN

1 E.T. The Extra - _____

2 Pulp _____

3 Gone with the _____

5 Schindler's _____

6 Blade _____

7 Star Wars: The Force _____

12 Lawrence of _____

14 One _____ Over the Cuckoo's Nest

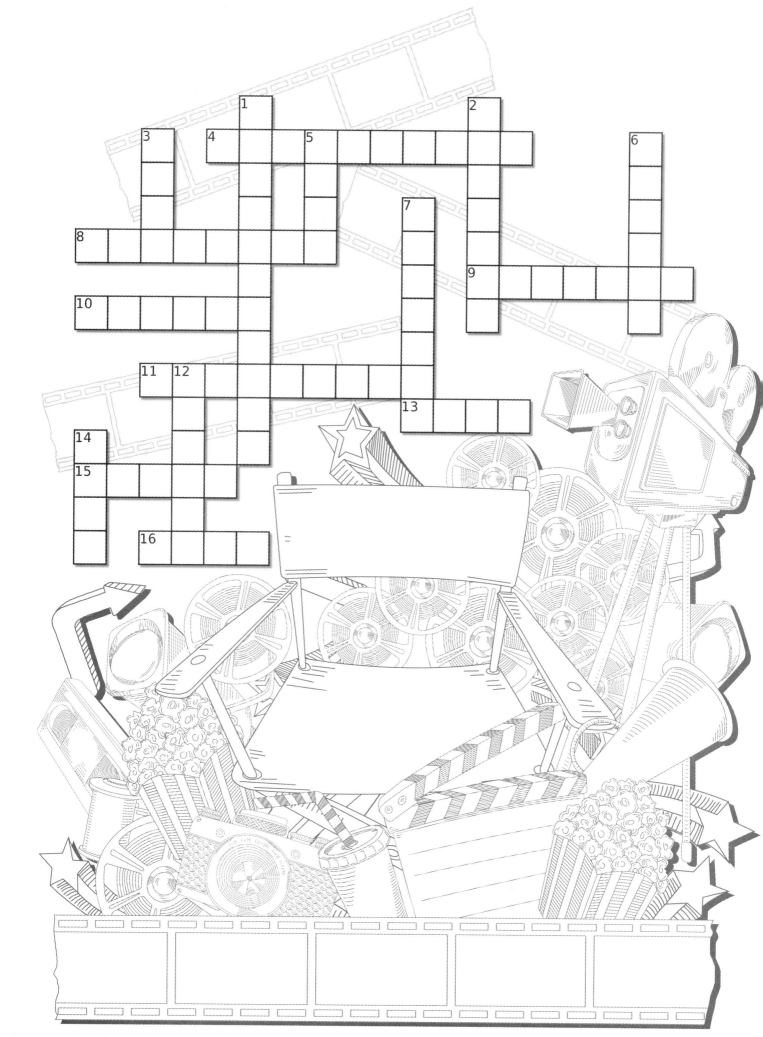

Fruit of the Bloom

ACROSS

1 James and the Giant _____
7 A color as well as a citrus fruit
8 A monkey's favorite fruit
11 The fruit Violet Beauregard turns into in "Willy Wonka & the Chocolate Factory"
12 Contains bromelain
13 Fruit of which Bing is a cultivar
14 Also a type of smartphone
15 Also known as muskmelon

DOWN

1 Fruit of which Anjou is a variety
2 "I'm sorry, but I can't elope."
3 Red fruit that was the subject of a Beatles song
4 Good for puckering lips
5 A raspy berry
6 Green and pink melon
9 Fruit used to make wine
10 The poisonous fruit Snow White eats

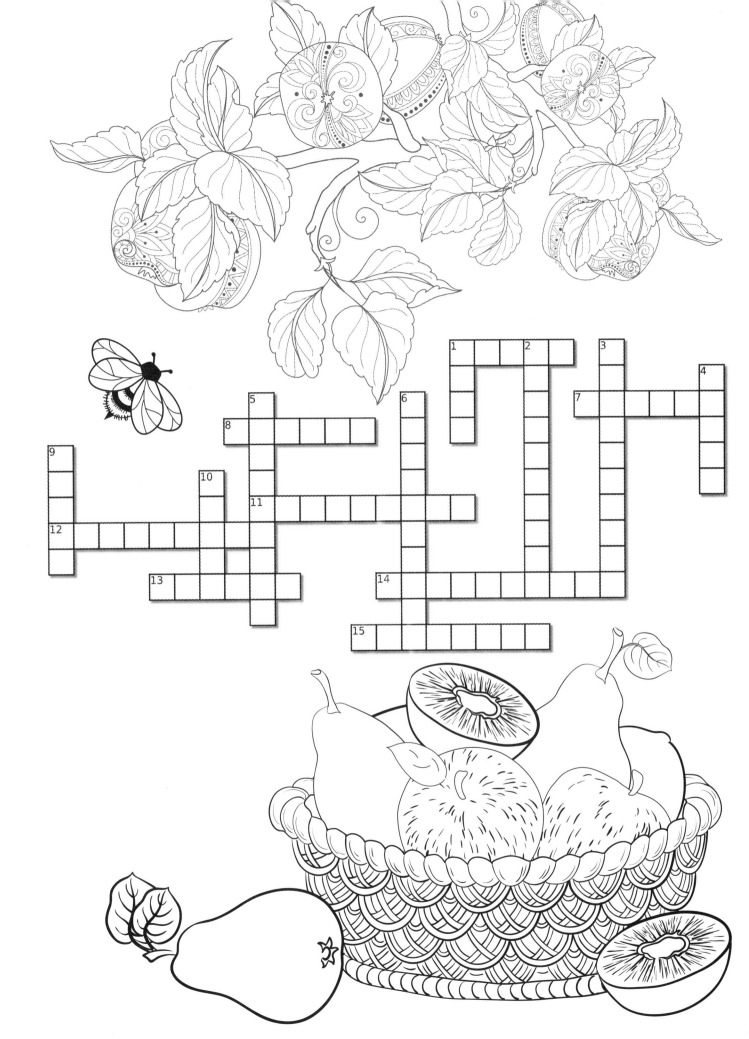

Disney Buff

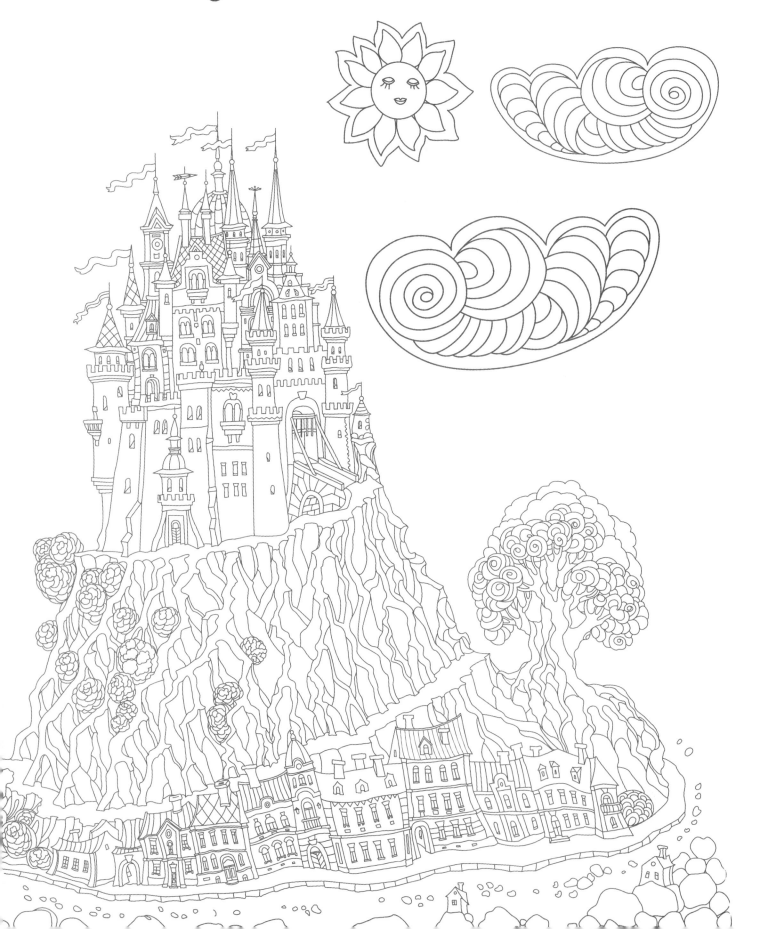

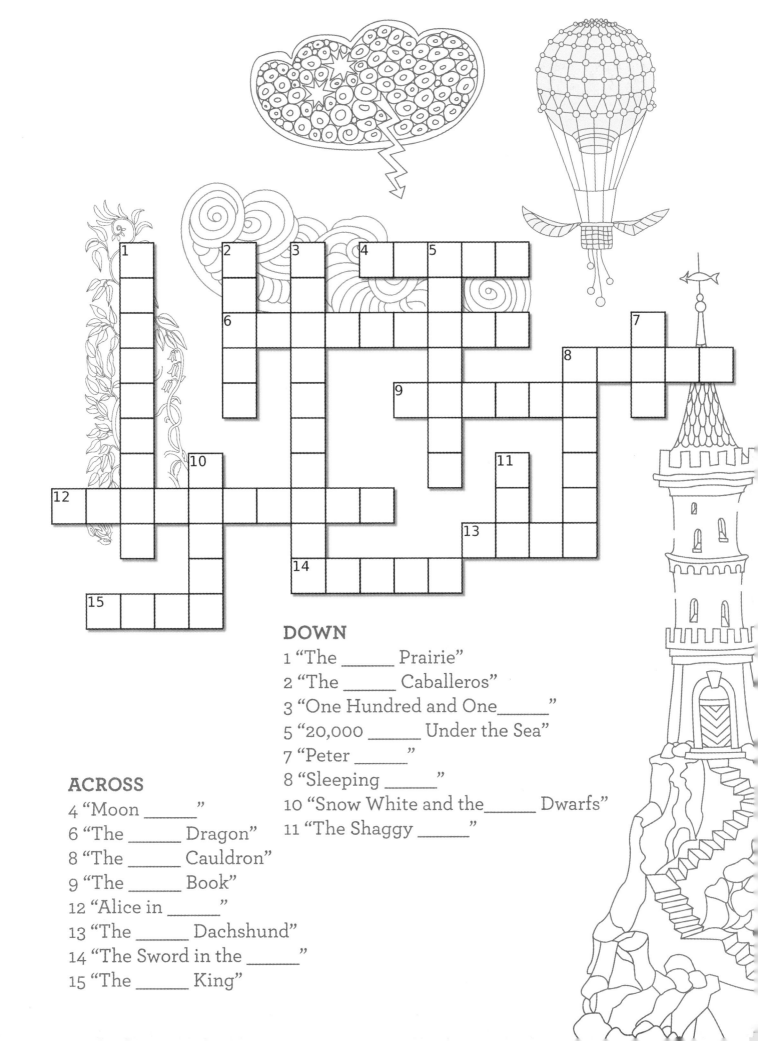

DOWN

1 "The _____ Prairie"
2 "The _____ Caballeros"
3 "One Hundred and One_____"
5 "20,000 _____ Under the Sea"
7 "Peter _____"
8 "Sleeping _____"
10 "Snow White and the_____ Dwarfs"
11 "The Shaggy _____"

ACROSS

4 "Moon _____"
6 "The _____ Dragon"
8 "The _____ Cauldron"
9 "The _____ Book"
12 "Alice in _____"
13 "The _____ Dachshund"
14 "The Sword in the _____"
15 "The _____ King"

Famous Dog Breeds

ACROSS

6 Astro in "The Jetsons"

7 Fang, Hagrid's dog from "Harry Potter"

10 Cujo makes this breed terrifying

11 The talking dog Frank in "Men in Black"

12 "Marley and Me"

14 Breed of Elle Woods' dog in "Legally Blonde"

15 The Breed of Lassie

16 Pete the Pup in "The Little Rascals"

DOWN

1 Terrier breed of Toto from "The Wonderful Wizard of Oz"

2 The breed of Airbud

3 Rin Tin Tin

4 Clifford the Big Red Dog

5 Spotted dog breed known for thwarting Cruella de Vil

8 Snoopy is a member of this breed

9 Terrier breed of Wishbone

13 "The Fox and the _____"

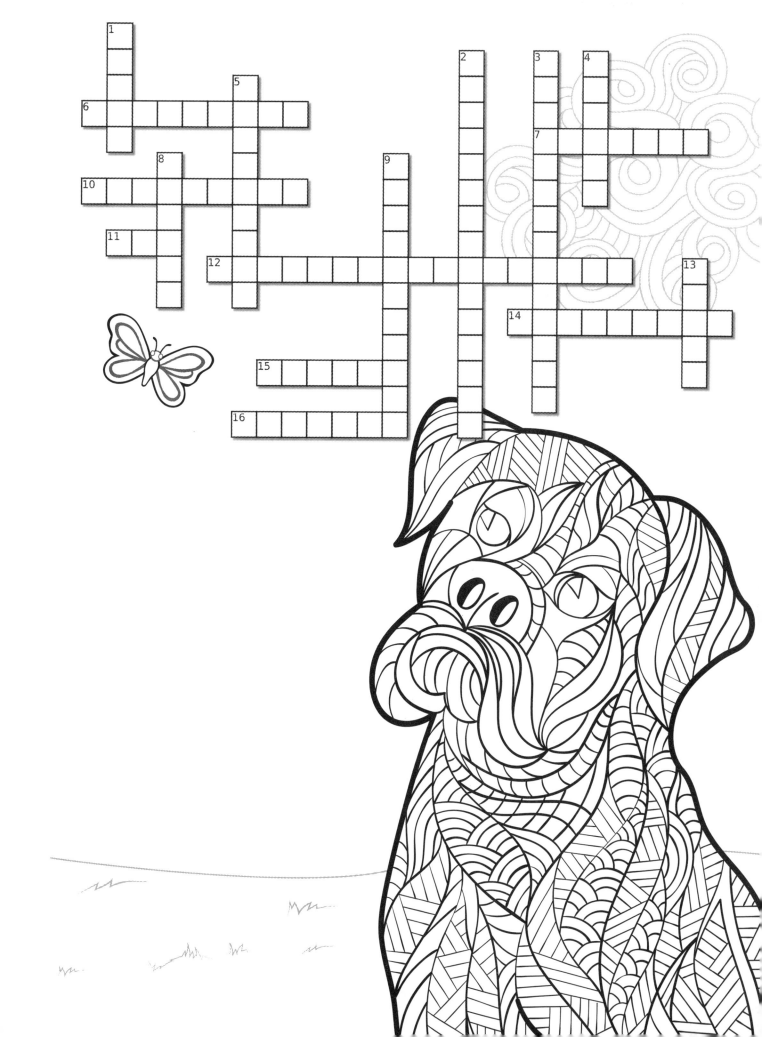

Notable Gems and Jewels

ACROSS

1 November birthstone that comes in a "mystic" variety
5 Gem guarded by clams
9 Name of the capital city of Oz
10 Another October birthstone derived from the Singhalese words "tura mali"
12 Rumored to have been named after Tsar Alexander II of Russia
13 Primary mineral source of the element Zirconium
14 Precious red birthstone of July
15 Purple birthstone of February

DOWN

1 Birthstone of December and popular jewelry choice of Native Americans
2 "Love of the Sea" precious gem that Kate Winslett wore in Titanic
3 Olive-green birthstone of August
4 "Is forever"
6 Also the name of a 2001 novel by Alice Hoffman
7 Rainbow birthstone of October
8 Dark red birthstone of January
11 Is often similar in color to many citrus fruits

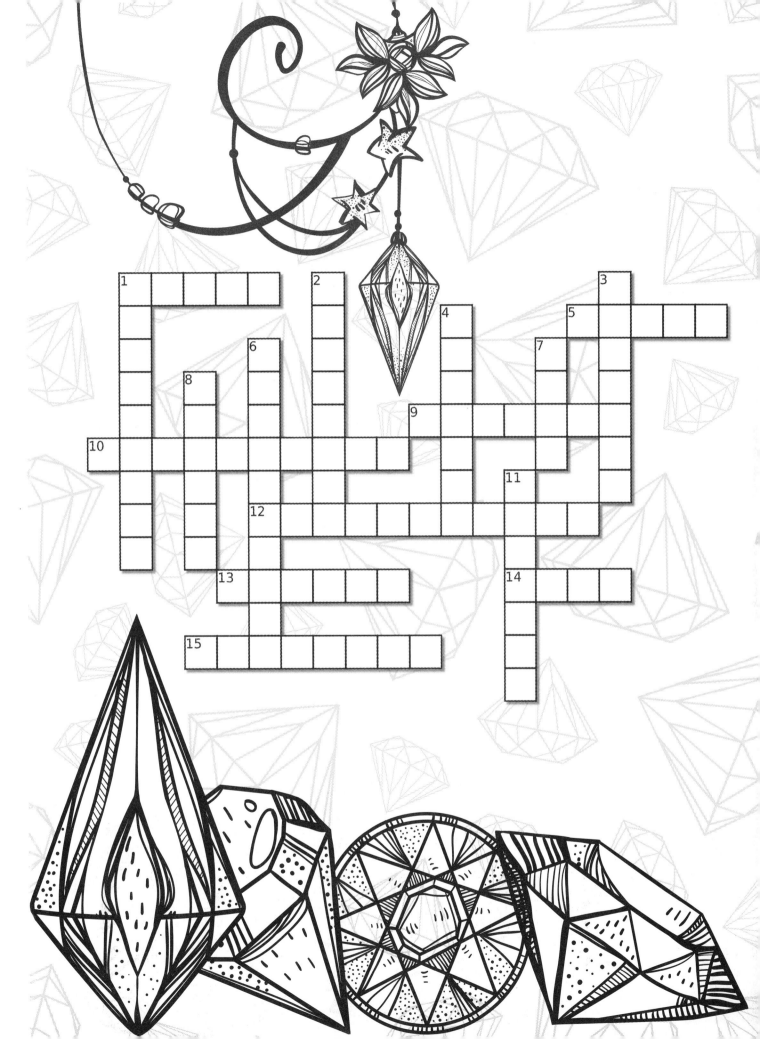

All-American Food

ACROSS

4 Fried potatoes
5 Essentially cucumbers in vinegar
7 Steak of Philadelphia
9 BBQ for short
10 Combination of Hershey chocolate, marshmallows, and graham crackers
11 Poultry most-commonly fried in the U.S.
14 Creamy condiment made from peanuts
15 Peanut butter and _____

DOWN

1 Type of hot wings
2 Sweet corn and lima beans
3 Good with tomato soup
5 New York makes it best
6 Meat patty originally from Germany
8 Poultry eaten on Thanksgiving
12 Nobody knows for sure what's in it
13 "As American as _____ pie."

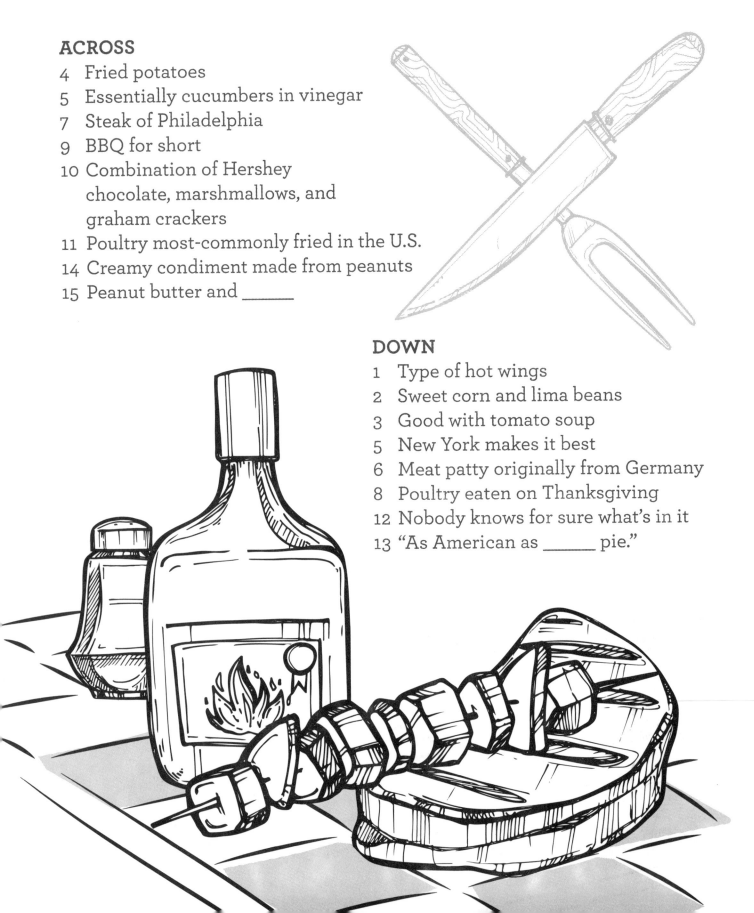

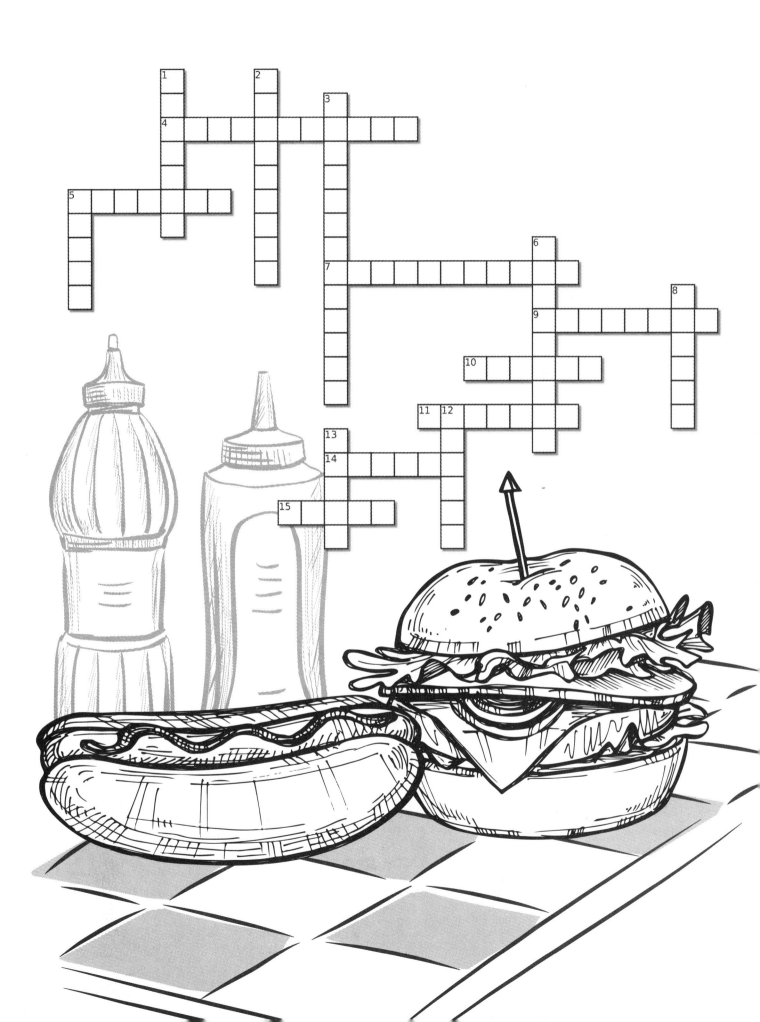

Crossword March *Madness*

ACROSS

2 _____ Bulldogs
4 _____ Blue Devils
5 _____ Spiders
9 _____ Cougars
10 Florida _____
12 _____ Tigers
13 Idaho _____
14 Auburn _____

DOWN

1 Vanderbilt _____
3 Kentucky _____
4 Albany Great _____
6 _____ Brook Seawolves
7 Alabama _____ Tide
8 _____ Owls
11 _____ Green Wave
14 Georgia _____ Yellow Jackets

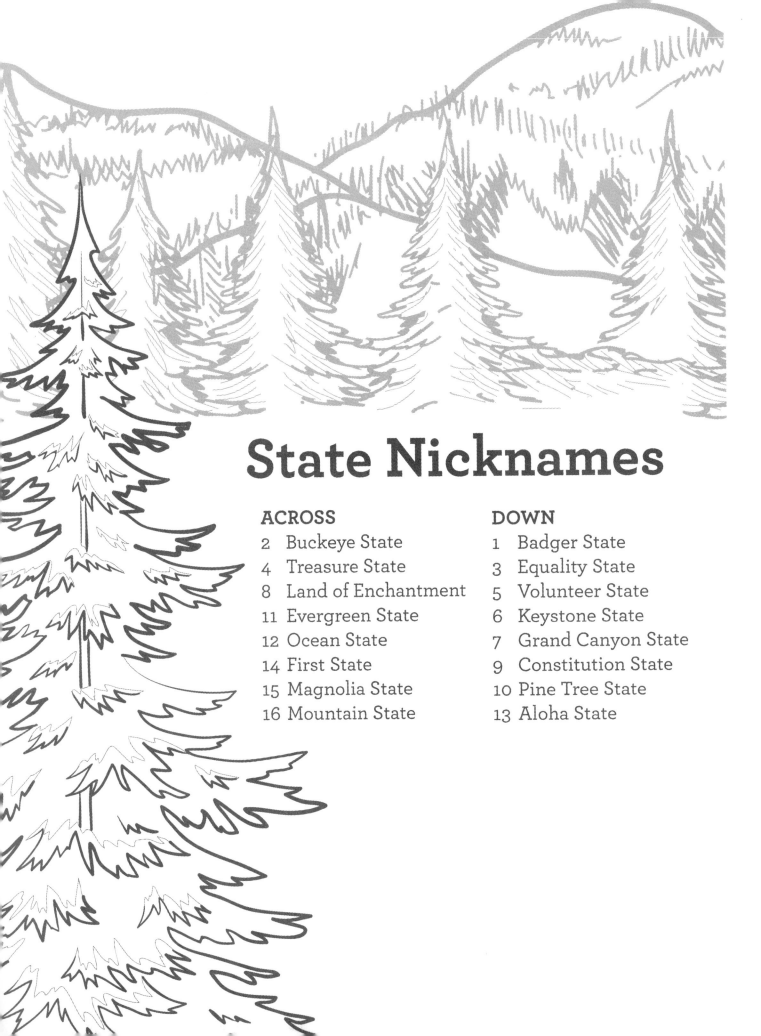

State Nicknames

ACROSS

2 Buckeye State
4 Treasure State
8 Land of Enchantment
11 Evergreen State
12 Ocean State
14 First State
15 Magnolia State
16 Mountain State

DOWN

1 Badger State
3 Equality State
5 Volunteer State
6 Keystone State
7 Grand Canyon State
9 Constitution State
10 Pine Tree State
13 Aloha State

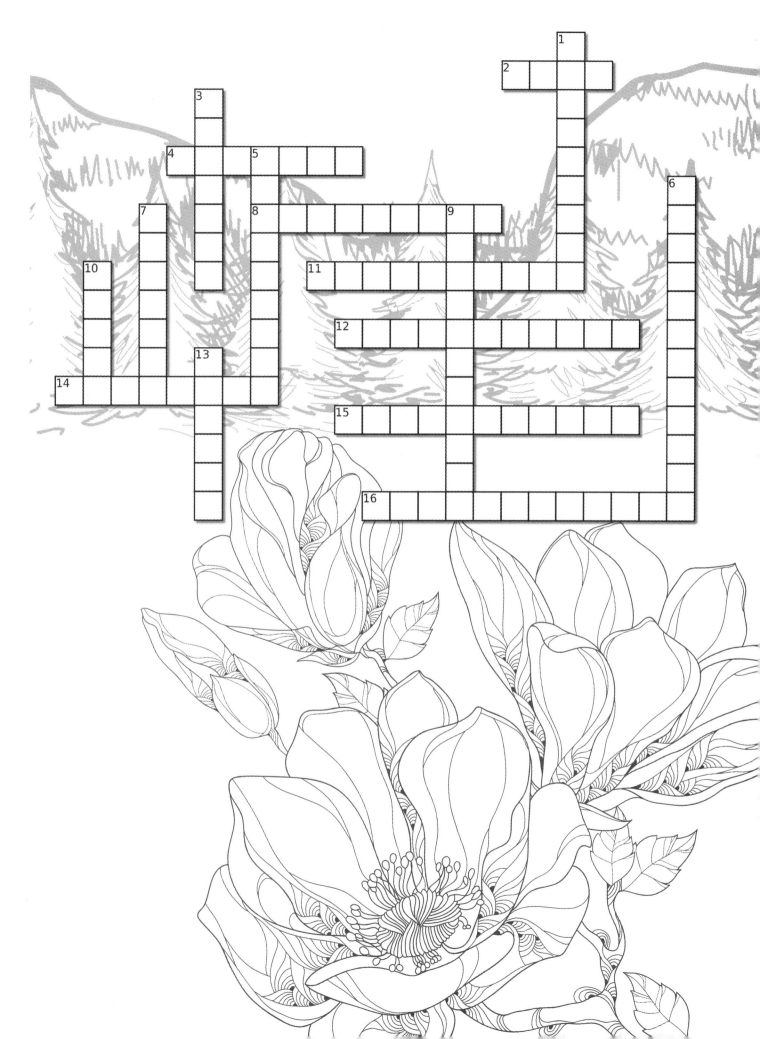

Rumi
Renowned Poet and Mystic

ACROSS

4 Showing forgiveness
7 A false god
8 Is often "seen as a virtue"
9 A feeling of deep affection
11 A trait that Bill Gates exhibits
12 Possessing both experience and good judgment
14 To center one's attention
15 Pleasing aesthetically

DOWN

1 "You lack _____"
2 A type of creative writer
3 The modern-day country that Rumi was born in
5 Opposite of arrogant
6 The language that Rumi primarily wrote in
7 The religion of Rumi
10 A logical explanation
13 Taken as true without question

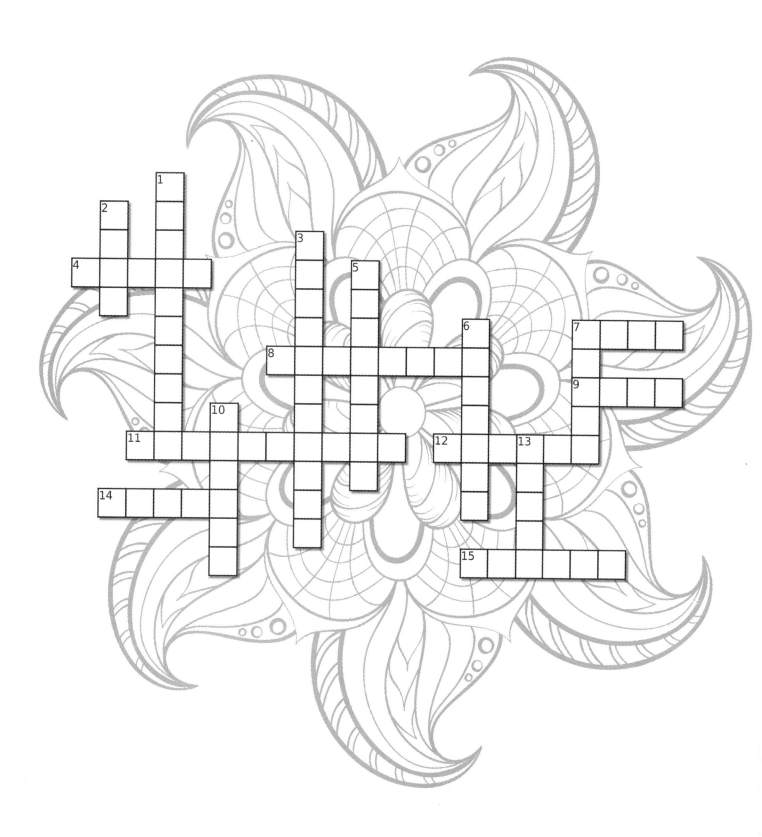

Chemistry 101

ACROSS

3 Subatomic particle with negative charge

4 Fourth state of matter; lightning is an example

8 Most rigid state of matter

9 Measure often confused with weight

10 Atom or molecule when number of protons and electrons are not equal

13 One who practices chemistry

14 Subatomic particle with positive charge

15 A combination of atoms held together by bonds

DOWN

1 A chemical change

2 Amount of space something occupies

3 When all influences are balanced

5 Smallest unit of matter

6 Steam is an example of this state of matter

7 State of matter between solid and gas

11 Subatomic particle with no charge

12 Force that holds something together

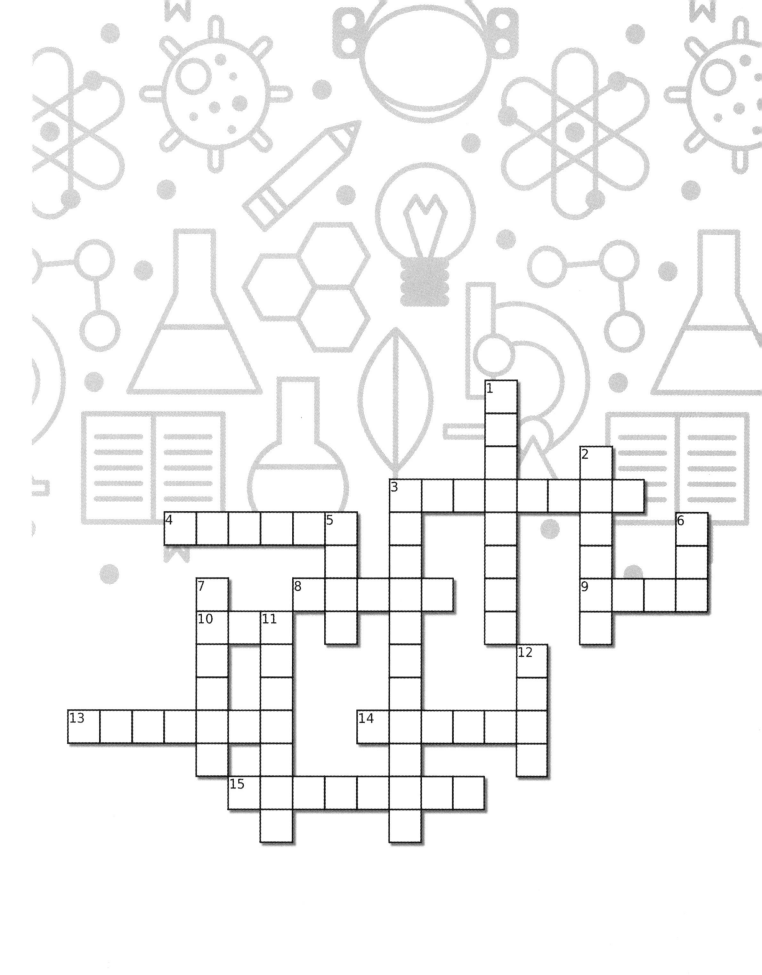

American Geography Extravaganza

ACROSS

6 Dover is the capital
7 Trenton is the capital
9 Columbus is the capital
11 Hartford is the capital
13 Charleston is the capital
14 Richmond is the capital
15 Harrisburg is the capital
16 Indianapolis is the capital

DOWN

1 Boston is the capital
2 Annapolis is the capital
3 Augusta is the capital
4 Montpelier is the capital
5 Concord is the capital
8 Providence is the capital
10 Albany is the capital
12 Lansing is the capital

The Ancient Practice of Henna Body Art

ACROSS

2 When love becomes a legal statement
5 A substance used to color something
8 Popular religion in India
9 Kat Von D is known for these
11 Felted or woven fabric
14 Something good for facial skin
15 Thick mixture of earth and water
16 Second most populous country in the world

DOWN

1 Karachi is in this country
3 A solution used to change the color of something
4 Also known as "make-up"
6 Fancy name for a skin rash
7 A very relaxing plant - and color
10 A vertically challenged tree
12 Flowering plant used to dye skin or hair
13 The national flower of India

Astronomy Crash Course

ACROSS

2 Large plasma sphere held together by gravity
6 Another name for the sun
7 Named after the Roman god of agriculture
10 The planet with a somewhat comical name
11 The third planet from the sun
12 The largest asteroid between Mars and Jupiter
14 Closest planet to the sun
15 The largest planet

DOWN

1 The red planet
3 Named after the Roman goddess of love and beauty
4 Used to be the ninth planet from the sun
5 Another name for the moon orbiting Earth
8 A large rocky object orbiting the sun
9 The planet's symbol is the trident
12 An icy object with a visible tail
13 Saturn has several around it

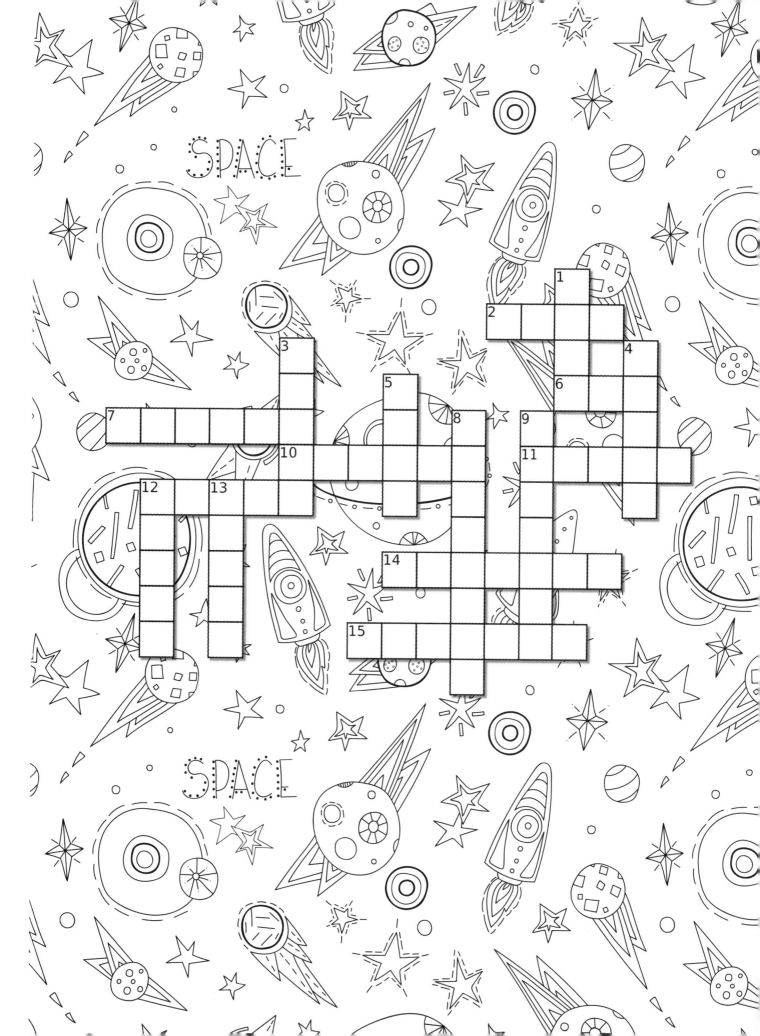

Are You Smarter than a 3rd Grader?

ACROSS

1 Capital of New Hampshire
6 Capital of Louisiana
10 Capital of Maryland
11 Capital of Michigan
12 Capital of Kentucky
13 Capital of Massachusetts
14 Capital of Montana
15 Capital of New York

DOWN

2 Capital of Nevada
3 Capital of Missouri
4 Capital of New Jersey
5 Capital of North Carolina
7 Capital of Mississippi
8 Capital of New Mexico
9 Capital of Nebraska
10 Capital of Maine

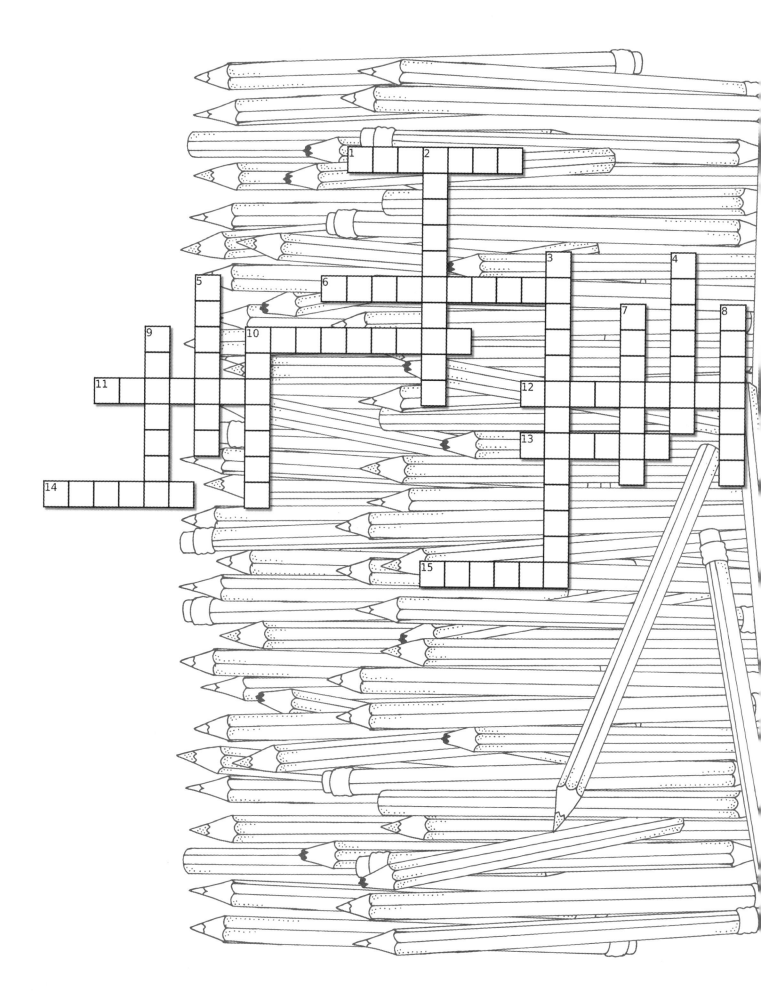

All That Glitters is Not GOLD

ACROSS

2 Makes up most of the Earth's core

5 Precious but soft yellow metal

6 Metal used to color other objects blue

8 Alloy of iron and carbon

9 Type of gold that is pink in color

13 Silvery metal often used in joint replacements

14 Used mostly for catalytic converters

15 Type of gold that is an alloy with a silvery metal

DOWN

1 Alloy of copper

3 Also the name for five cents

4 Alloy of copper and zinc

7 Also known as wolfram

9 Similar to "rodeo" if it were written in Latin

10 Silvery metal considered even more valuable than gold

11 Reddish-orange metal used for electrical wiring

12 Associated with moonlight and considered second to gold in value

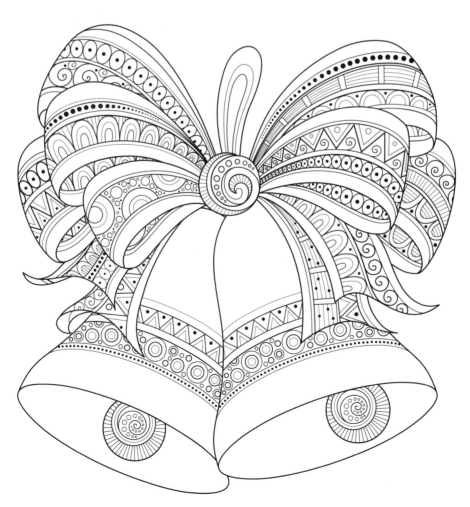

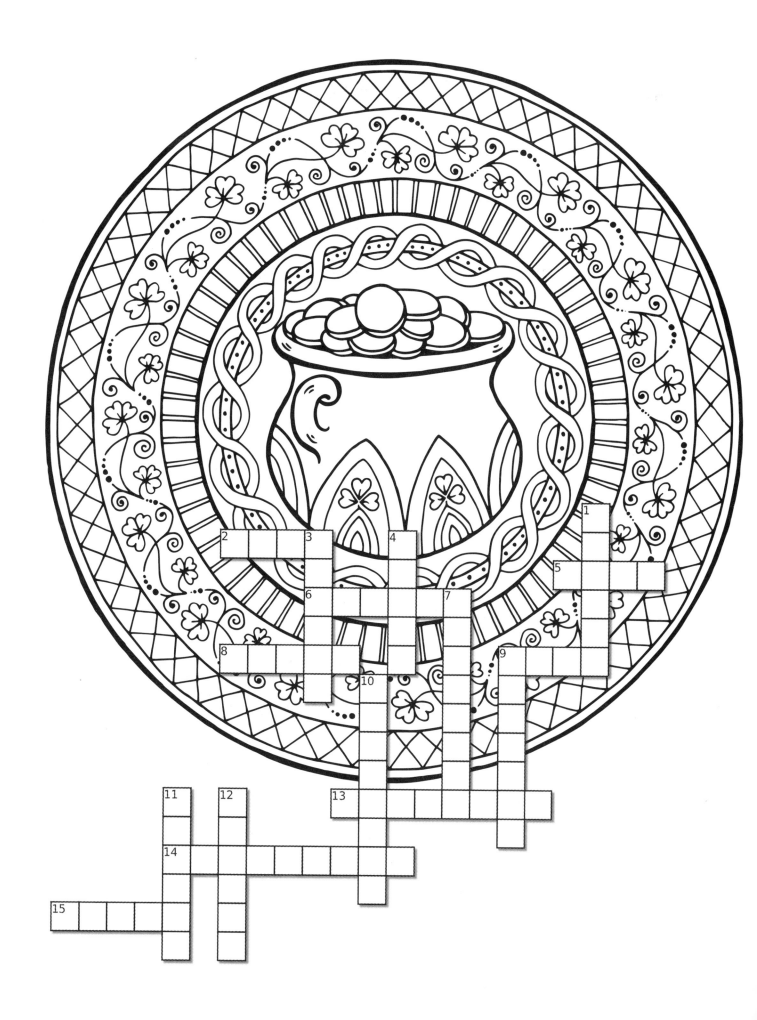

Do You Have a Green Thumb?

ACROSS

2 Bright yellow and sour fruits that only grow in certain climates
3 A "wise herb"
6 Also called "muskmelon"
8 Berries that are good for preserving memory
9 The indispensable herb pairing with tomato
12 An herb critical for flavoring guacamole and salsa
13 A staple fruit in Italian cuisine
14 Also called "zukes"

DOWN

1 Harvested by the ear
2 Hardy green salad vegetable that grows in most climates
3 Delicious red berry by itself or dipped in chocolate
4 Seedy pink melon
5 Also called "cukes"
7 "Black beauty" is a variety of this plant
10 Often used as a flavor for chewing gum
11 "Cherry belle" is a variety of this root vegetable

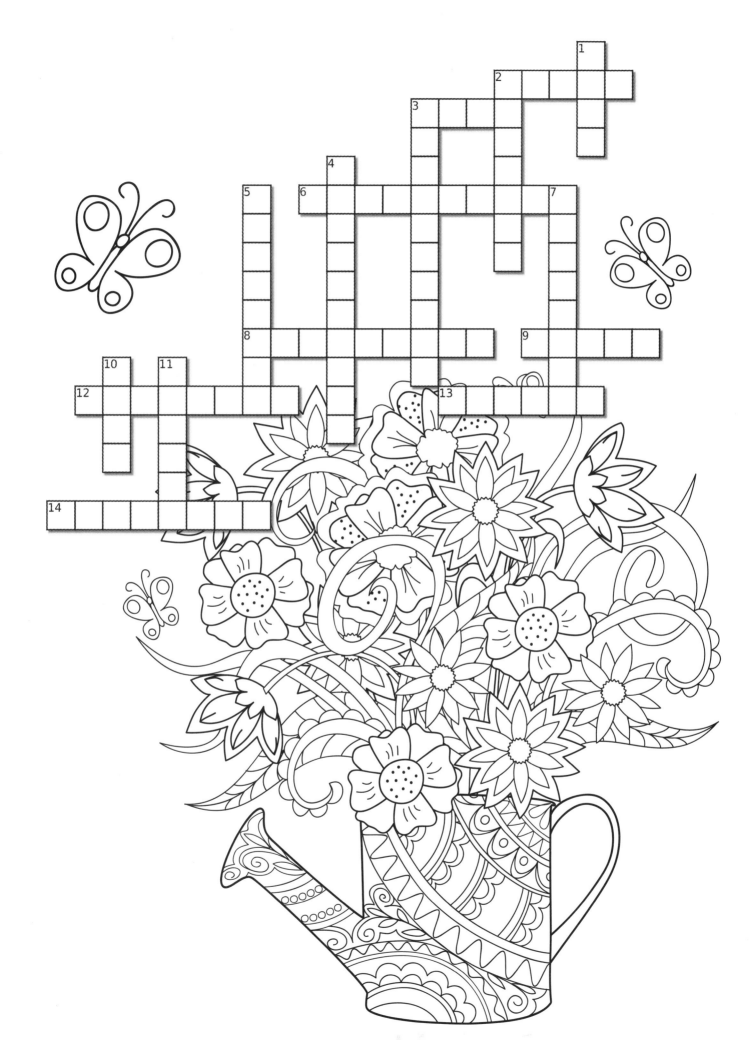

Are You Smarter than a 4th Grader?

ACROSS

6 Capital of Tennessee
9 Capital of Vermont
10 Capital of Virginia
11 Capital of Washington
12 Capital of Pennsylvania
13 Capital of Ohio
14 Capital of Rhode Island
16 Capital of Utah

DOWN

1 Capital of West Virginia
2 Capital of South Carolina
3 Capital of North Dakota
4 Capital of Texas
5 Capital of Oklahoma
7 Capital of Wisconsin
8 Capital of Oregon
15 Capital of South Dakota

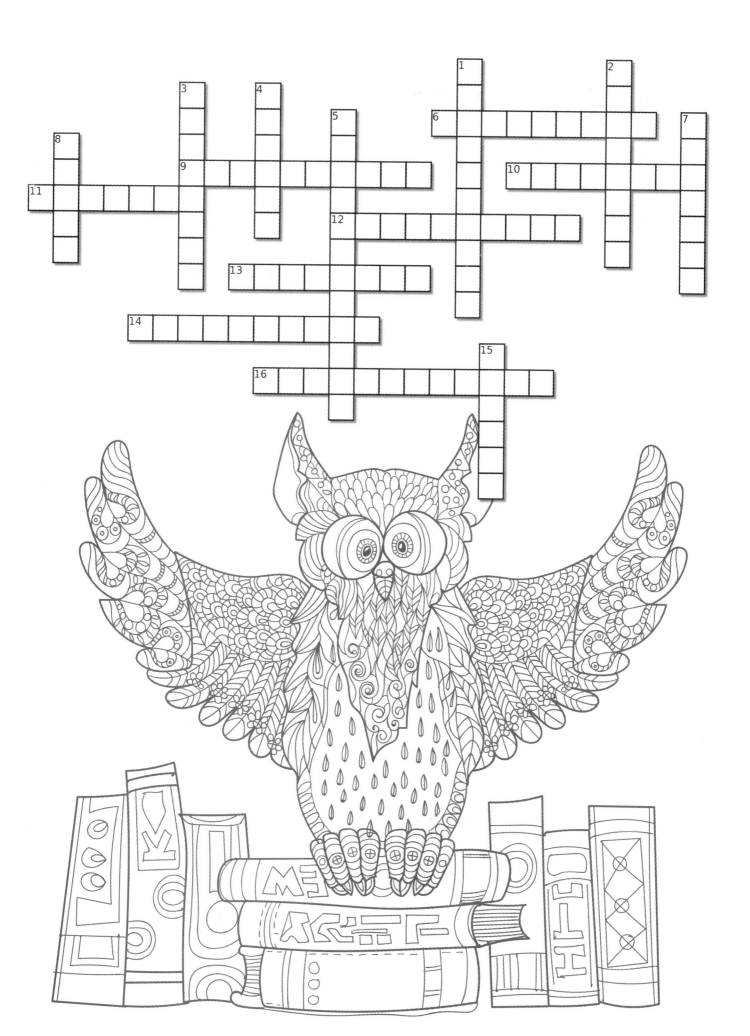

Crossword March *Madness* Returns

ACROSS

5 NC _____ Wolfpack
7 SMU _____
8 New Mexico State _____
9 _____ Panthers
11 _____ Orange
12 Ole Miss _____
14 Western Carolina _____
16 Louisiana Lafayette Ragin'

DOWN

1 _____ Golden Hurricane
2 Tennessee _____
3 _____ Forest Demon Deacons
4 LSU _____
6 Georgia Southern _____
10 Texas State _____
13 _____ Bears
15 _____ Midshipmen

Diplomat Training

ACROSS

4 Vladimir Putin is the president
8 Rio de Janeiro is located in this country
9 The Eiffel Tower is in this country
10 The country with the most people
12 Also called the United Kingdom
14 Scandinavian country associated with the Vikings
15 Cairo and the pyramids are in this country
16 Real Madrid football club is based in this country

DOWN

1 Athens and the Parthenon are in this country
2 Raul Castro is the current president
3 Helsinki is the capital
5 Angela Merkel is the Chancellor
6 Northern neighbor of the United States
7 Southern neighbor of the United States
11 Rome, Florence, and Naples are in this country
13 Stockholm is the capital

Biology 101

ACROSS

1 The energy production center of a cell
5 A slow one often leads to weight gain
7 Multicellular organisms that are typically green and grow
11 An organized system of cells
13 Process of passing traits from parents to offspring
14 The opposite of death
15 Ebola is an example
16 Multicellular organisms like lizards, mammals, and birds

DOWN

2 Green organelles in plants
3 Most basic component of any living organism
4 One who practices biology
6 The process of the development of life over long spans of time
8 The "brain" of a cell
9 The "good" kind is in yogurt
10 Molecular unit that determines heredity
12 Homo sapiens is an example

Emotional Train Wreck

ACROSS

3 Feeling of impending danger
5 A strong feeling of dislike for someone or something
6 Feeling anxious
9 The emotion felt when something unexpected happens
11 Wanting what someone else has
12 Feeling at peace
13 Strong feeling of revulsion
15 Feeling a lack of interest in anything

DOWN

1 To feel guilty
2 A strong feeling of adoration for someone or something
4 To not know
5 Associated with a smile
7 Insecurity about losing someone or something
8 An atagonistic emotion toward someone or something
10 Taking joy in who one is or one's accomplishments
14 Feeling of sorrow

Are You Smarter than a 5th Grader?

ACROSS

2 Capital of Georgia
8 Capital of Delaware
9 Capital of Alabama
10 Capital of Arkansas
13 Capital of Connecticut
14 Capital of Alaska
15 Capital of Indiana
16 Capital of Iowa

DOWN

1 Capital of Hawaii
3 Capital of Illinois
4 Capital of Colorado
5 Capital of Idaho
6 Capital of Florida
7 Capital of California
11 Capital of Kansas
12 Capital of Arizona

Crosswords: The Fashionista Edition

ACROSS

2 One-piece garment that covers even the legs

4 Sleeveless garment worn over a shirt covering the waist

6 Loose-fitting upper garment typically worn by women

9 Pants made of typically blue denim

10 Woman's garment that partially covers the legs

12 Type of shirt with the same name as a sport

14 Knitted garment with long sleeves

15 What one wears in very formal settings

DOWN

1 Type of shoes for women that are difficult to walk in

3 Short pants that only typically reach the knees

5 Material worn around the collar of a dress shirt

7 Casual trousers

8 A light outer garment

10 Used to cover feet

11 A heavy outer garment

13 Used to keep pants up

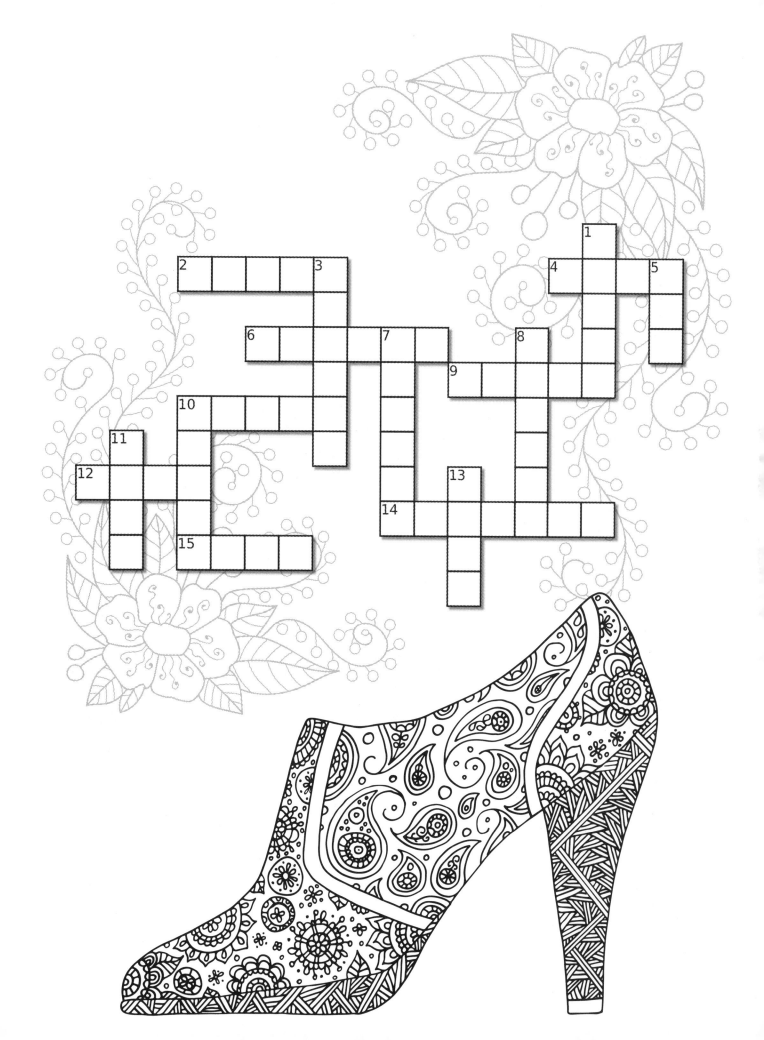

Are You a Renaissance Man... or Woman?

ACROSS

4 The study of rocks and minerals
5 Associated with chemicals and beakers
11 Study of numbers
12 The study of societies and behavior at large
13 Evolution is critical to understanding this field
14 The scientific study of water
15 Scientific study of climate
16 Scientific study of animals

DOWN

1 Spock's favorite thing in "Star Trek"
2 The field of Einstein
3 Often confused with astrology
6 Study of humanity
7 The study of the mind and behavior
8 Study of the atmosphere
9 The field of Indiana Jones
10 Study of organisms relating to their environment

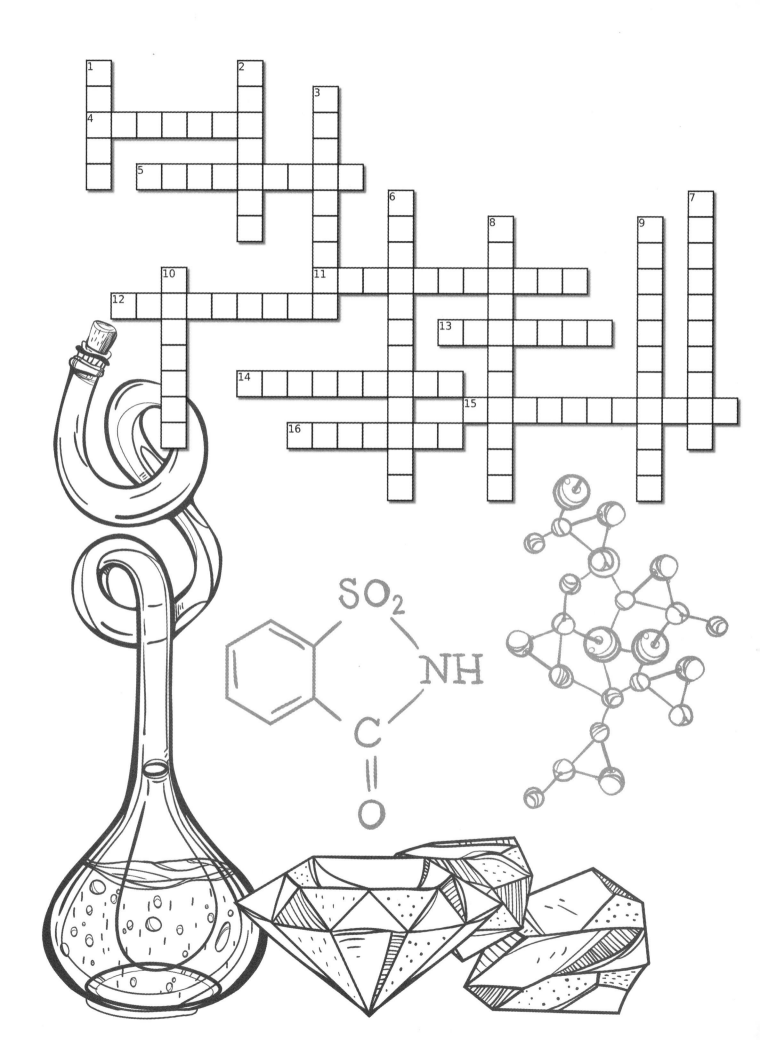

Diplomat Training Revisited

ACROSS

5 Mulatu Teshome is the current president
8 Fuad Masum is the current president
10 Country with the same name as a bird
11 Hassan Sheikh Mohamoud is the president
12 Country associated with sushi
13 Lisbon is the capital
14 Tripoli is the capital
15 Kabul is the capital

DOWN

1 Abuja is the capital
2 Bogota is the capital
3 Nawaz Sharif is the prime minister
4 Nairobi is the capital
6 Machu Picchu is located in this country
7 Caracas is the capital
9 Both a country and a continent
10 The country that inspired "The Lion King"

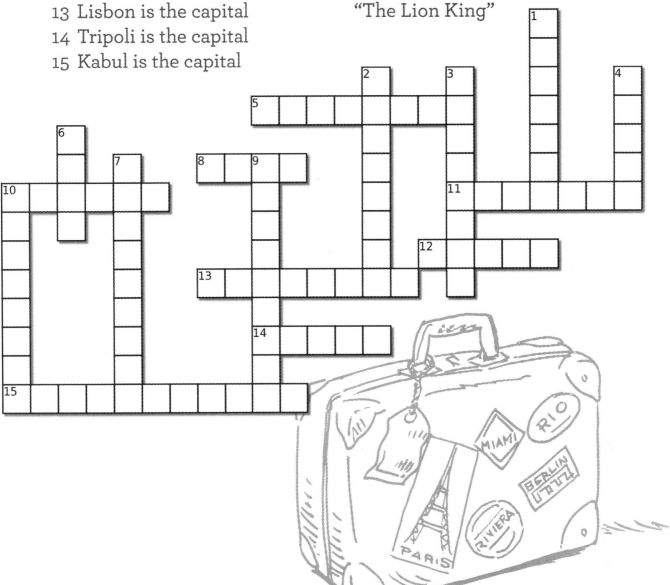

Astronomy Course: Stephen Hawking Difficulty

ACROSS

1 The name of our galaxy
4 Phenomenon of attraction between objects
6 Charged particles released from the sun's upper atmosphere
9 Possible result after a massive star explodes
10 When a massive star explodes
11 Sudden flash of light on the sun's surface
13 Nearest galaxy to ours
15 The smallest and densest type of star

DOWN

2 The opposite of a black hole
3 All of time and space
5 The final stage of a star's life
7 A very dense remnant of a star
8 Interstellar cloud of dust and gases
9 Objects between the size of a planet and a star
12 Name for a system of two stars
14 Shortened term for pulsating radio star

Insect Aficionado

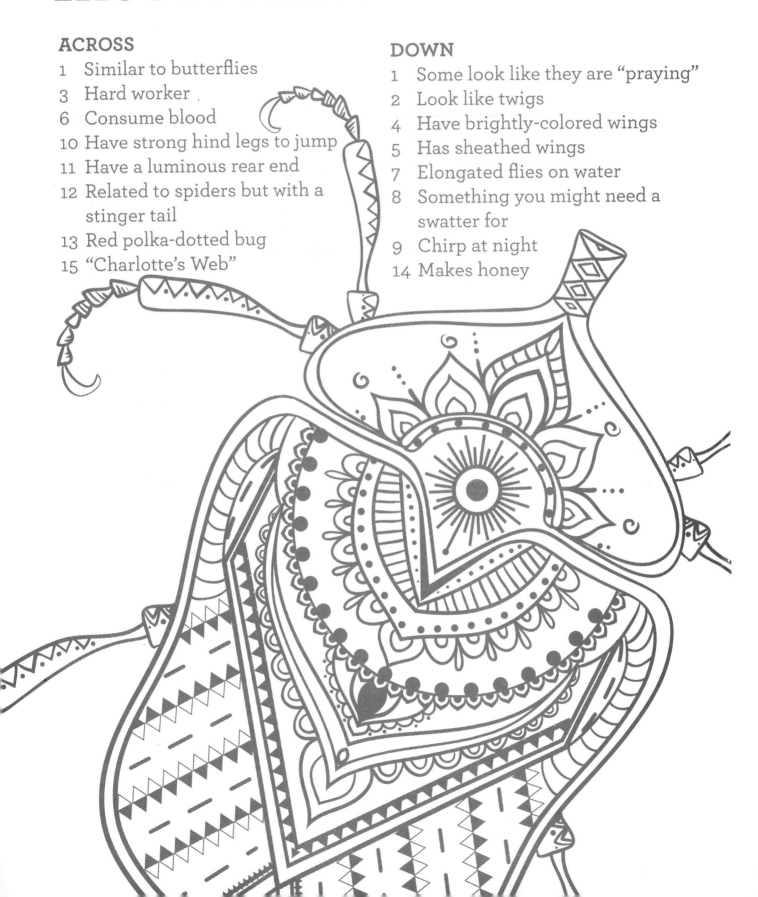

ACROSS

1 Similar to butterflies
3 Hard worker
6 Consume blood
10 Have strong hind legs to jump
11 Have a luminous rear end
12 Related to spiders but with a stinger tail
13 Red polka-dotted bug
15 "Charlotte's Web"

DOWN

1 Some look like they are "praying"
2 Look like twigs
4 Have brightly-colored wings
5 Has sheathed wings
7 Elongated flies on water
8 Something you might need a swatter for
9 Chirp at night
14 Makes honey

Mother Nature Has a Mean Temper

ACROSS

2 Spews lava
5 Hard ice pellets that fall from the sky
6 A severe lack of water
9 A severe lack of food
10 Another name for rampant disease
12 When the ground shakes uncontrollably
14 A massive wave
15 Also called a cenote, swallow hole, or swallet

DOWN

1 An overflow of water
3 When a mixture of snow and ice tumbles down a mountain
4 Fires that burn out of control in places like forests
5 Tropical cyclones that form in the Atlantic
7 Prolonged period of excessive heat
8 Also called an electrical storm
11 Also called a mudslide
13 A violently rotating column of air

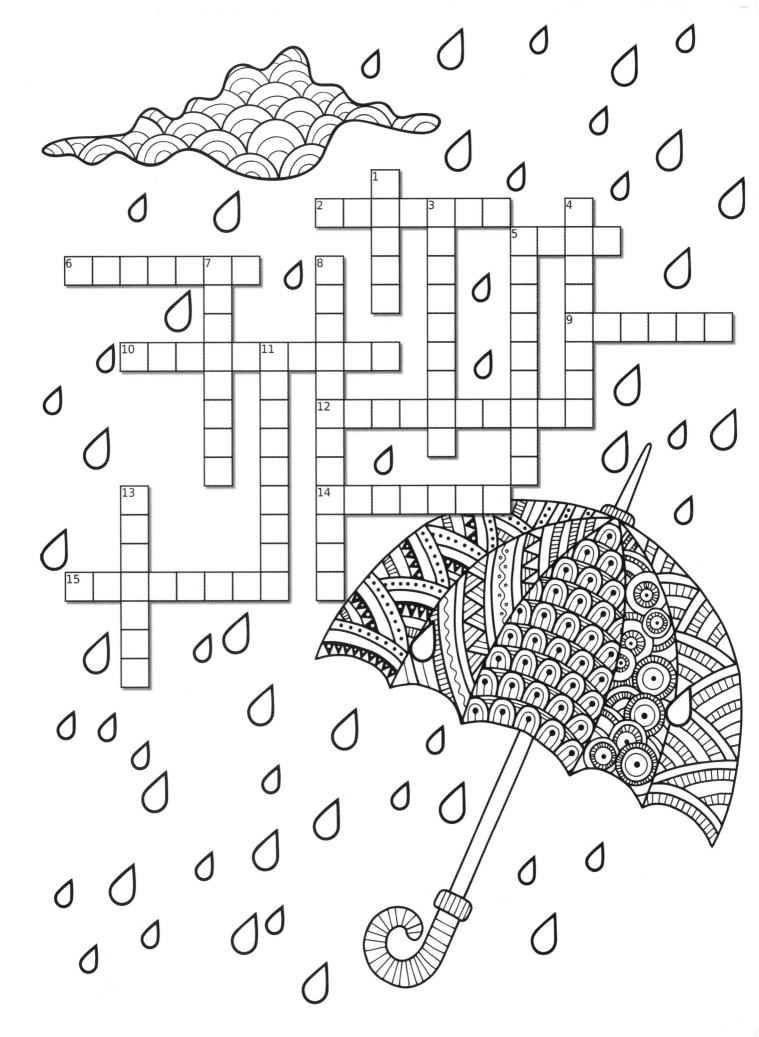

Crossword March Madness: The Final Chapter

ACROSS

4 Penn _____

5 _____ Black Bears

7 Yale _____

8 Columbia _____

11 Florida A&M _____

12 Brown _____

15 _____ Phoenix

16 _____ Wildcats

DOWN

1 _____ College Blue Hose

2 Harvard _____

3 _____ Madison Dukes

6 Towson _____

9 _____ & Mary Tribe

10 Dartmouth Big _____

13 Rhode Island _____

14 Cornell Big _____

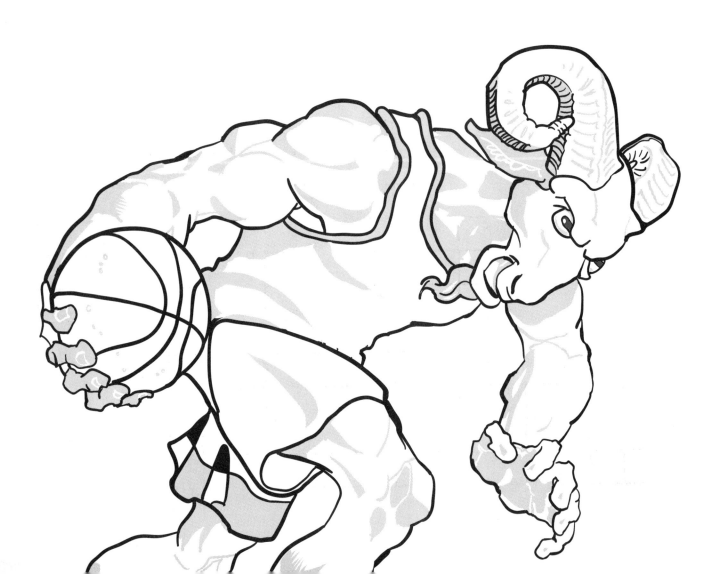

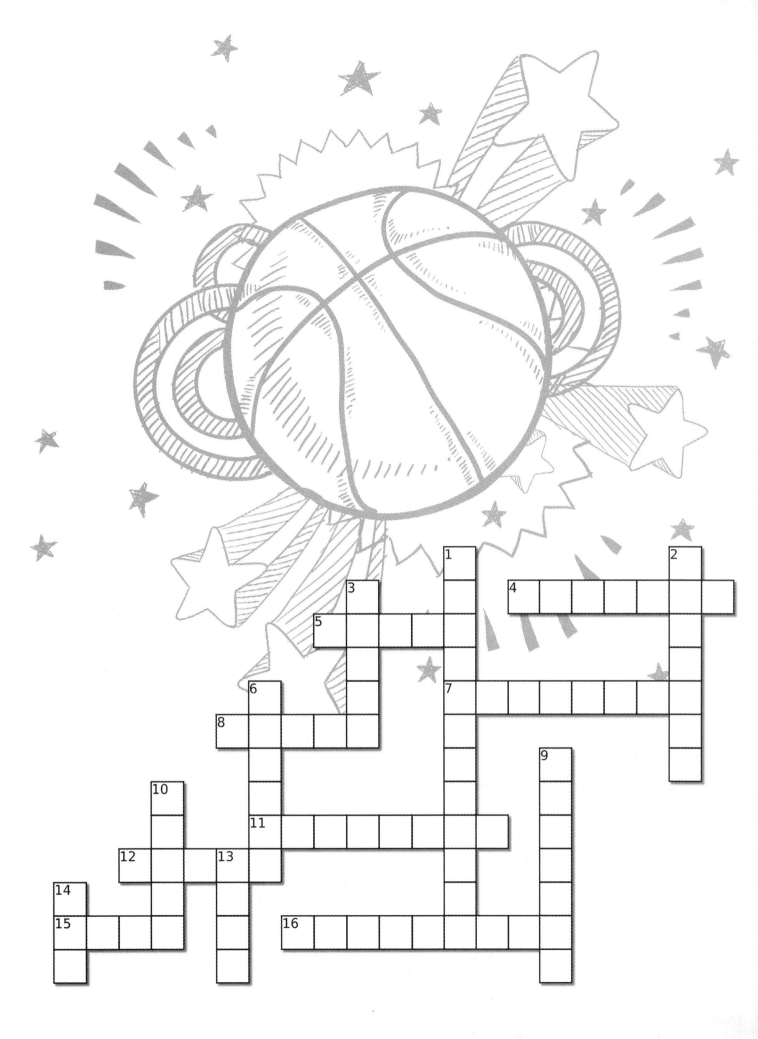

American Geography Extravaganza Revisited

ACROSS

2 Austin is the capital
5 Raleigh is the capital
8 Atlanta is the capital
10 Baton Rouge is the capital
13 Jackson is the capital
14 Jefferson City is the capital
15 Oklahoma City is the capital
16 Montgomery is the capital

DOWN

1 Frankfort is the capital
3 Phoenix is the capital
4 Columbia is the capital
6 Little Rock is the capital
7 Nashville is the capital
9 Santa Fe is the capital
11 Springfield is the capital
12 Tallahassee is the capital

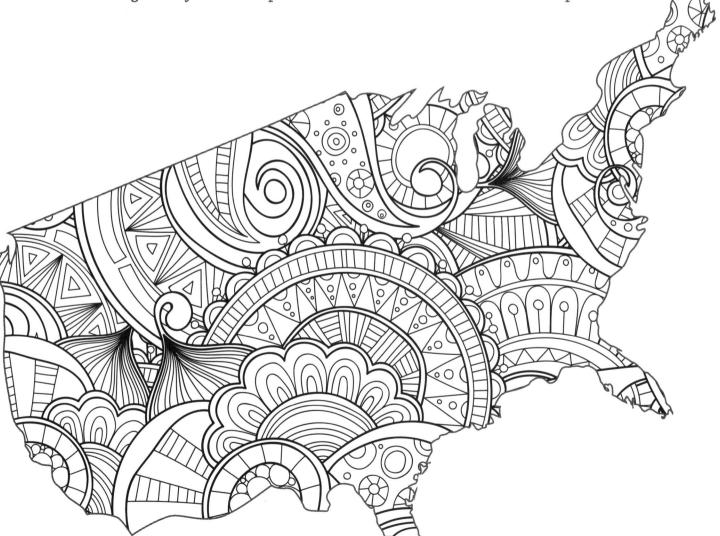

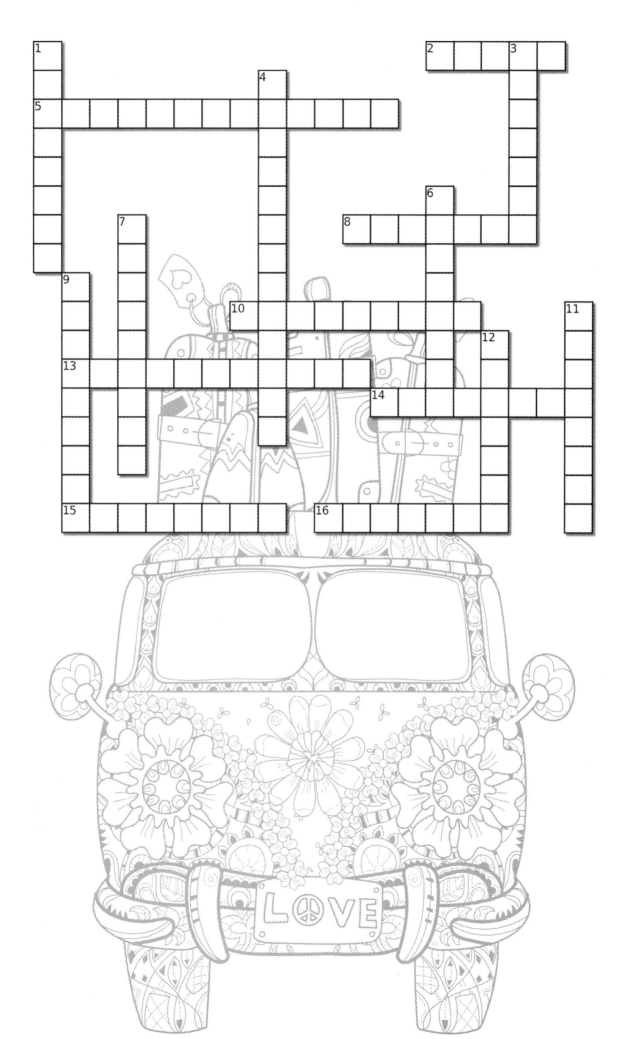

"I'll Be Back"

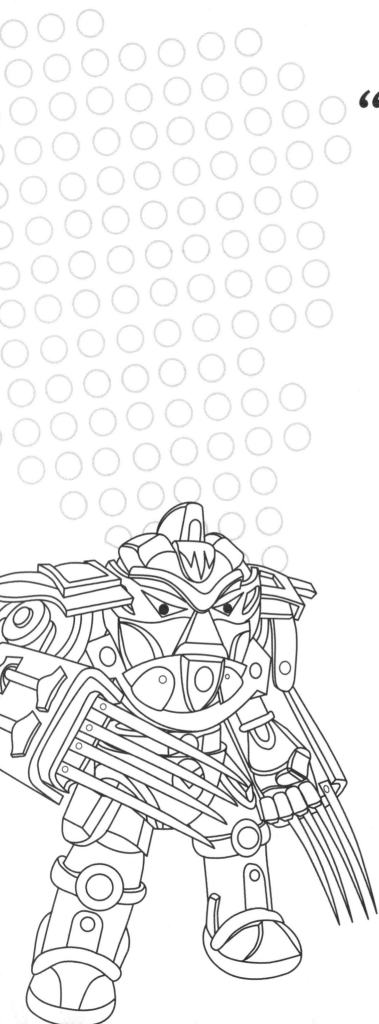

ACROSS

3 Android that Gohan defeats in "Dragon Ball Z"

4 Abbreviation of Virtual Interactive Kinetic Intelligence in "I, Robot"

5 Cyborg general in "Star Wars: Revenge of the Sith"

8 Name of hostile A.I. in "The Terminator" series

9 Arnold Schwarzenegger

11 Fictional AI in "2001: A Space Odyssey"

DOWN

1 Sentient machine race of Sovereign in the "Mass Effect" series

2 Avengers villain

4 Darth _____ in "Star Wars"

5 Machine race in "Mass Effect"

6 "Squiddy" robots in "The Matrix"

7 Half machine character in "Teen Titans Go!"

10 Name of the Russian space station in the 1999 film "Virus"

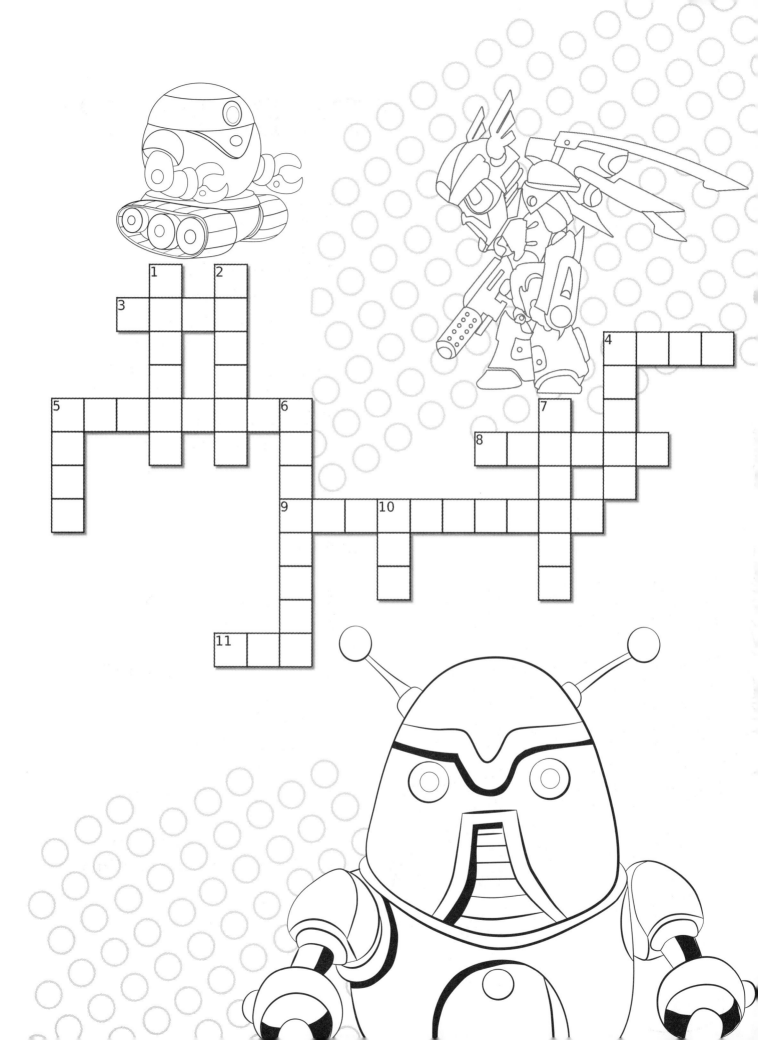

Diplomat Training:
Secretary of State Difficulty

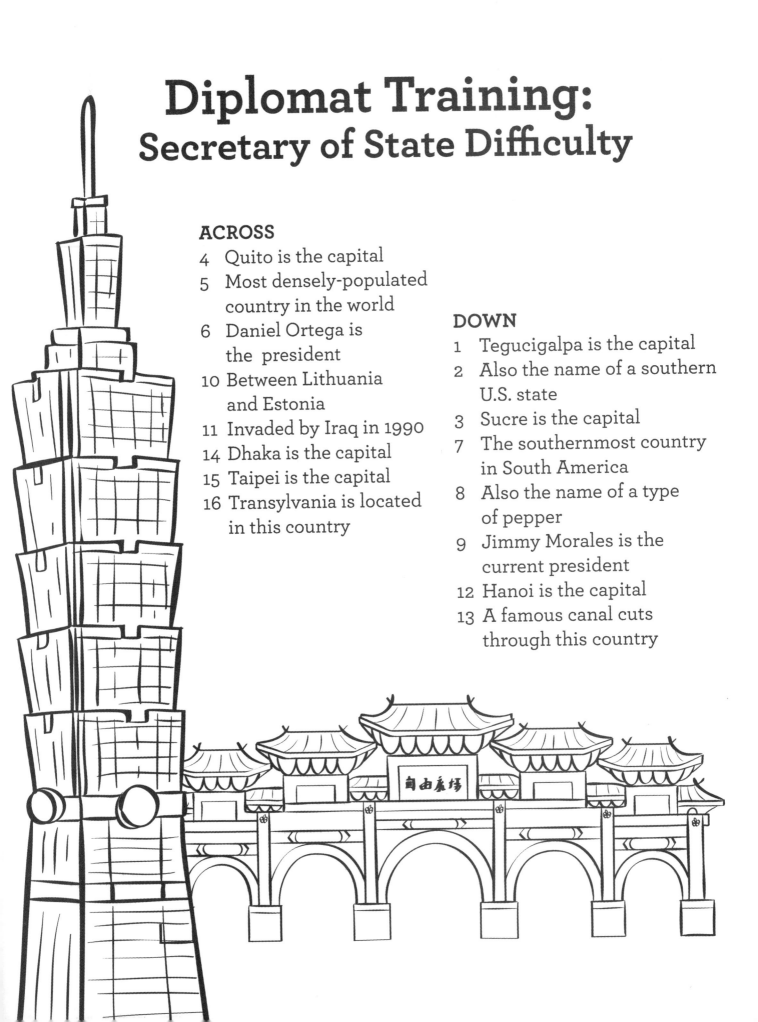

ACROSS

4 Quito is the capital

5 Most densely-populated country in the world

6 Daniel Ortega is the president

10 Between Lithuania and Estonia

11 Invaded by Iraq in 1990

14 Dhaka is the capital

15 Taipei is the capital

16 Transylvania is located in this country

DOWN

1 Tegucigalpa is the capital

2 Also the name of a southern U.S. state

3 Sucre is the capital

7 The southernmost country in South America

8 Also the name of a type of pepper

9 Jimmy Morales is the current president

12 Hanoi is the capital

13 A famous canal cuts through this country

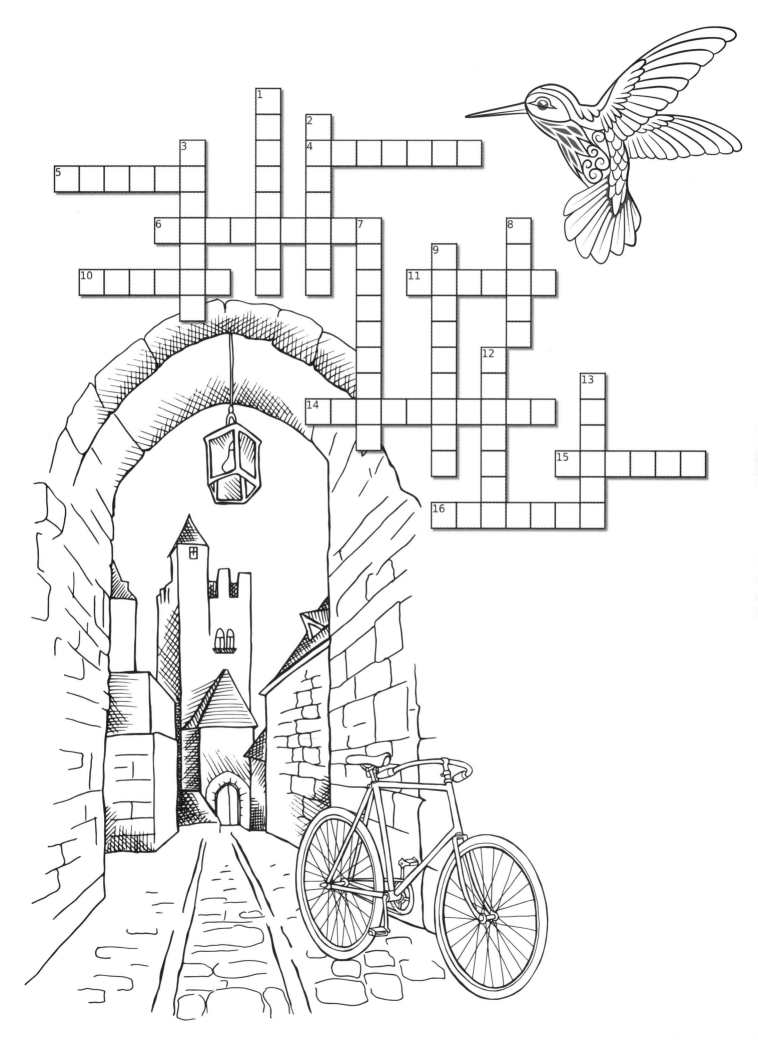

American Geography Extravaganza
FINALE

ACROSS

3 Des Moines is the capital
4 Topeka is the capital
8 Boise is the capital
10 Sacramento is the capital
13 Lincoln is the capital
14 Cheyenne is the capital
15 Juneau is the capital
16 Denver is the capital

DOWN

1 Salt Lake City is the capital
2 Madison is the capital
5 Helena is the capital
6 Olympia is the capital
7 St. Paul is the capital
9 Salem is the capital
11 Honolulu is the capital
12 Carson City is the capital

"It's Not Easy Being Cheesy"

ACROSS

3 Greek cheese made from mixing sheep and goat milk

7 Italian nutty and sweet cheese

9 Italian cheese that is grated or shredded

11 Famous French cheese made from soft cow's milk

12 Similar to bleu cheese but with peppery and tangy flavor

14 One of the most popular cheeses originating in England

15 Similar in spelling to "monster"

16 Salty cheese curd often served with fruit

DOWN

1 White cheese with blue streaks that is often crumbled

2 The cheese with holes in it

4 Italian white cheese similar to parmesan with many different textures

5 Similar to cheddar but has orange color

6 Italian cheese with mellow flavor used in sandwiches

8 Processed yellow cheese

10 Italian cheese that is used in caprese salads

13 Dutch yellow cheese

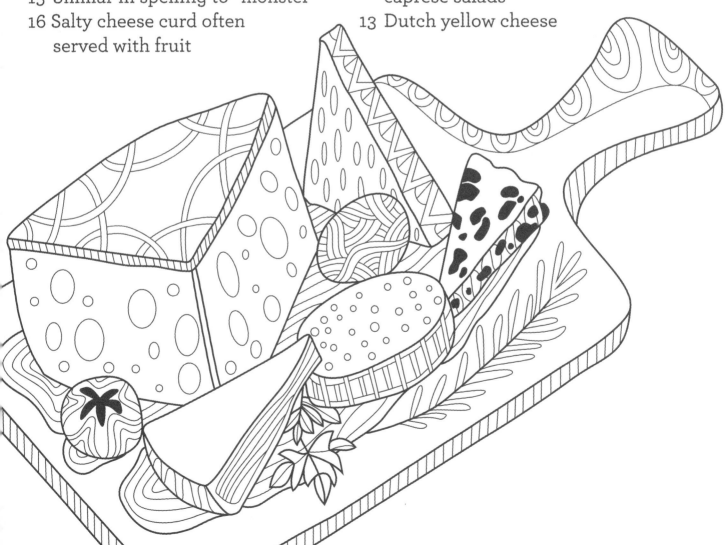

Laissez-Faire

ACROSS

2 Manufacturer of fine Italian leather
3 Britney Spears did a commercial for them
4 Largest engineering company in Europe
7 American pale beer lager
9 Popular Scandinavian furniture chain
12 Nesquick is produced by this company
13 Also the name for a type of travel document
14 Founded by Henry Ford

DOWN

1 United Parcel Service
2 Associated with shaving products
5 Popular coffee producer that isn't Starbucks
6 Best selling brand of cigarettes
8 Japanese car manufacturer
10 German automobile manufacturer symbolized by four interlocking rings
11 Most popular sports broadcasting company
14 American broadcasting company named after a sly mammal

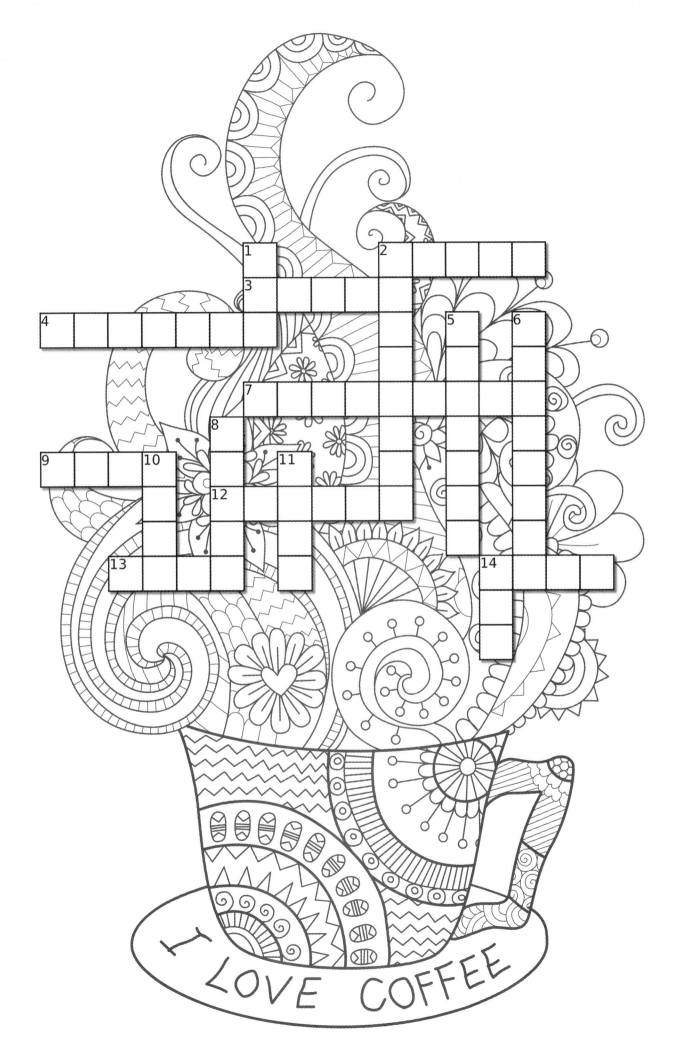

Math Nerds Unite!

ACROSS

1 Branch of math concerned with properties of numbers
3 Operation of adding two numbers
6 Type of number that includes an imaginary number
8 The basis of all of mathematics
12 Type of number expressed as a fraction or quotient
13 Branch of math concerned with shapes and figures
14 Operation name for $\sqrt{\ }$
16 Operation of multiplying two numbers

DOWN

2 Branch of math concerned with studying triangles
4 Operation of dividing two numbers
5 Branch of math concerned with mathematical symbols
7 Operation of subtracting two numbers
9 Type of number with no fractions or decimals
10 Type of number used for counting and ordering
11 Branch of math concerned with studying change
15 Type of number on a continuous line

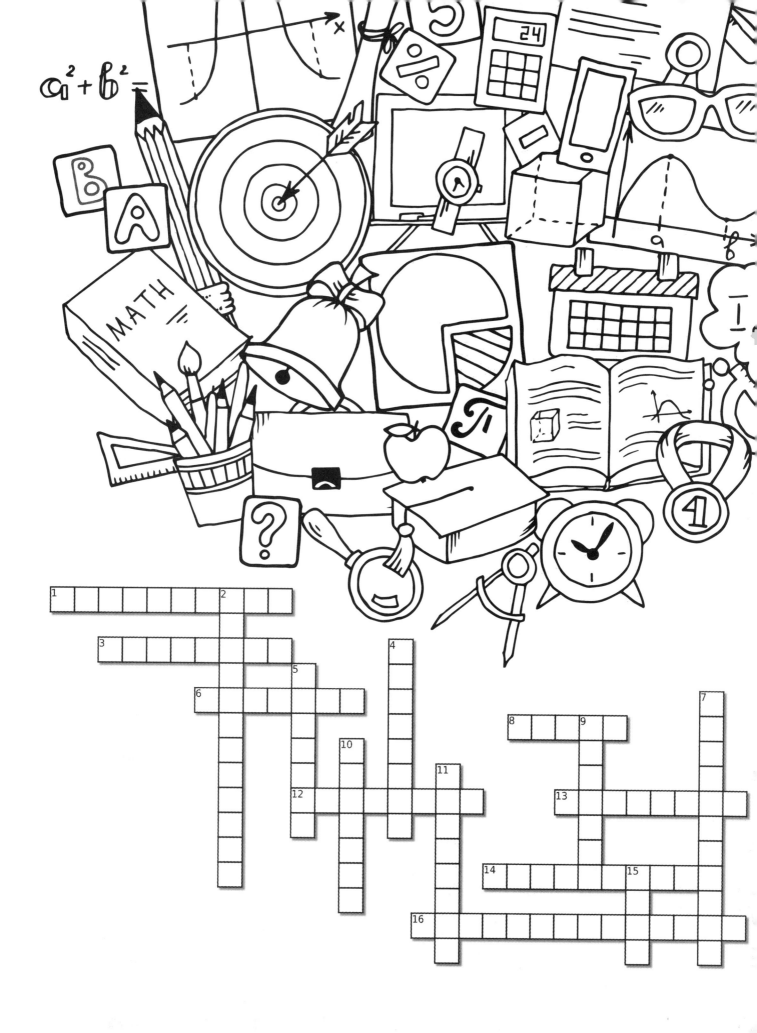

Forbes Picks

ACROSS

1 American multinational conglomerate corporation that makes electronics
5 Japanese automobile company
6 Steve Jobs
7 Bill Gates
10 California company that makes computer software and hardware
11 Mickey Mouse
13 "Just Do It"
15 Bayerische Motoren Werke AG

DOWN

1 Most-used search engine
2 Internet retailer named after a rainforest
3 American multinational company for IT
4 Controversially battling net neutrality
8 South Korean company that makes many electronics
9 Most popular social media site
12 Multinational California company known for making semiconductors
14 Short form of International Business Machines Corporation

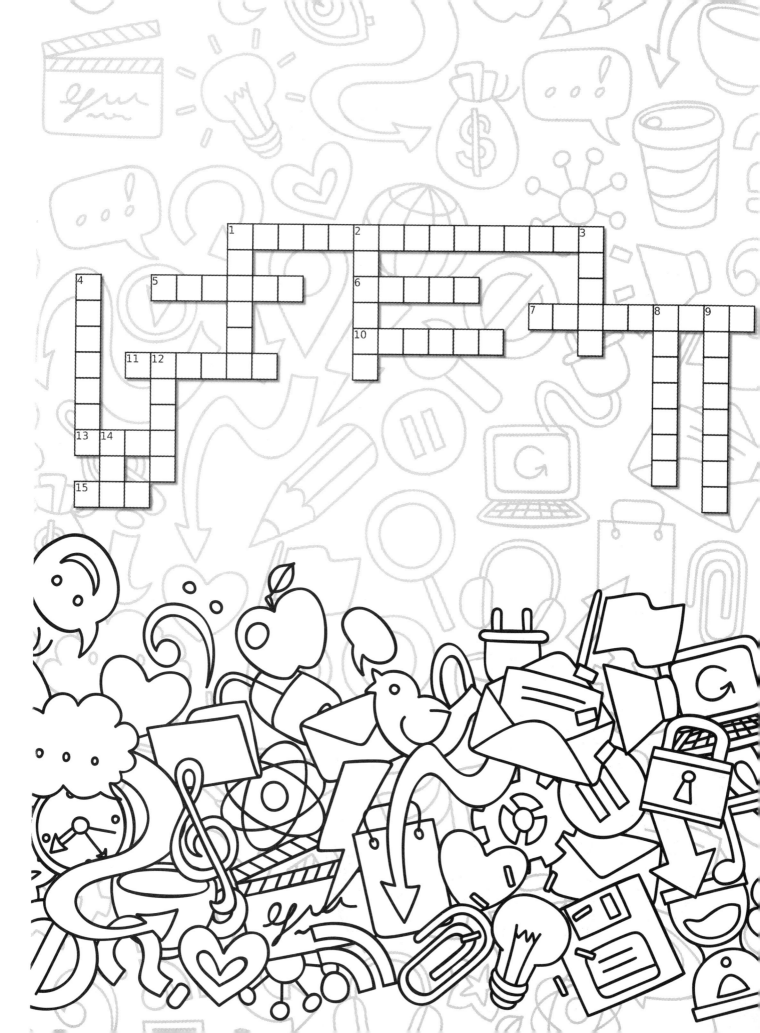

MLB Madness

ACROSS

5 Texas _____
6 Atlanta _____
9 St. Louis _____
10 Miami _____
13 Seattle _____
14 _____ City Royals
15 _____ White Sox
16 _____ Phillies

DOWN

1 Los Angeles _____
2 _____ Astros
3 New York _____
4 _____ Diamondbacks
7 _____ Red Sox
8 _____ Orioles
11 Tampa Bay _____
12 San Diego _____

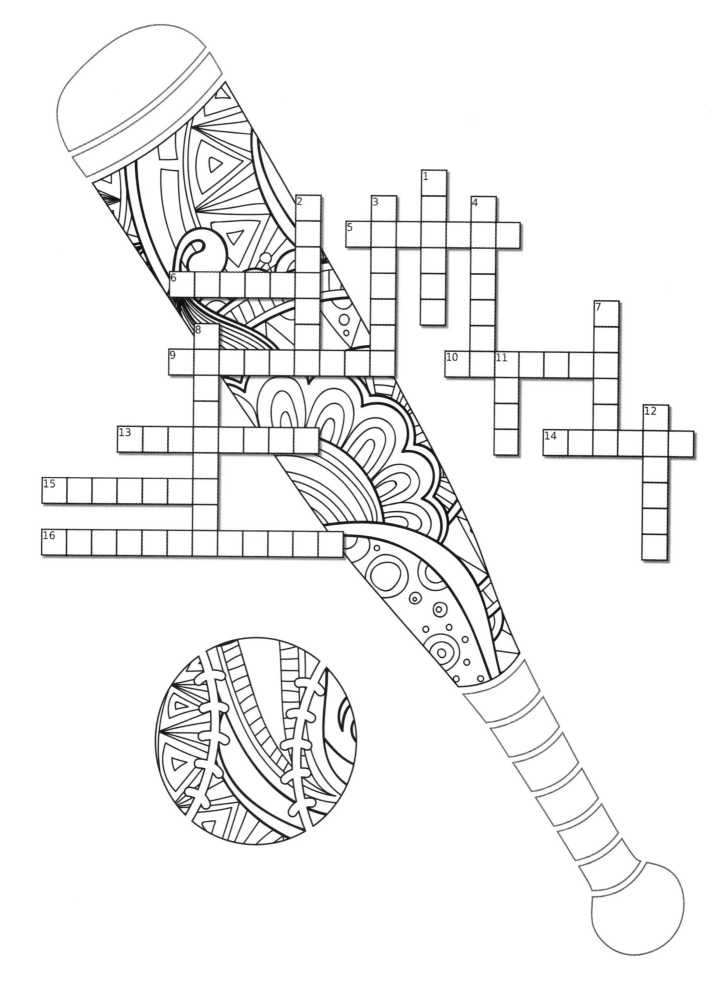

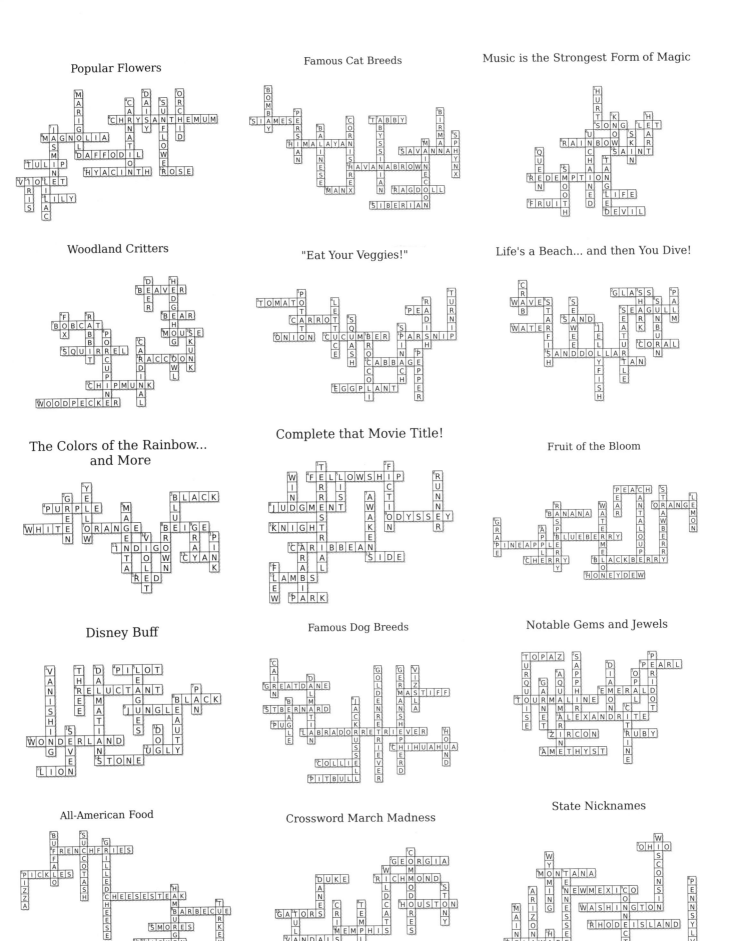

Popular Flowers

Famous Cat Breeds

Music is the Strongest Form of Magic

Woodland Critters

"Eat Your Veggies!"

Life's a Beach... and then You Dive!

The Colors of the Rainbow...
and More

Complete that Movie Title!

Fruit of the Bloom

Disney Buff

Famous Dog Breeds

Notable Gems and Jewels

All-American Food

Crossword March Madness

State Nicknames

Rumi: Renowned Poet and Mystic

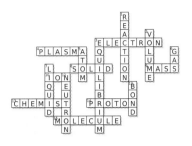

Chemistry 101

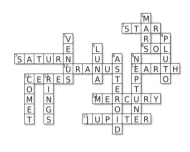

American Geography Extravaganza

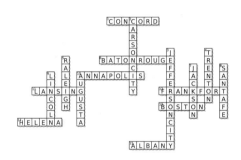

Mehndi: The Ancient Practice of Henna Body Art

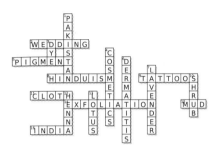

Astronomy Crash Course

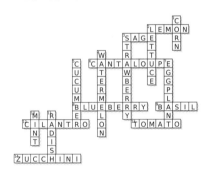

Are You Smarter than a 3rd Grader?

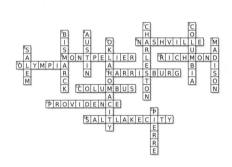

All That Glitters is Not Gold

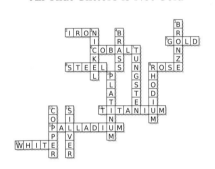

Do You Have a Green Thumb?

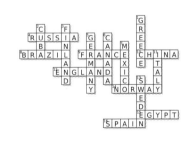

Are You Smarter than a 4th Grader?

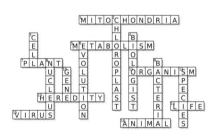

Crossword March Madness Returns

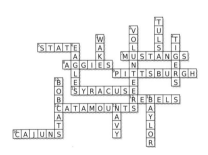

Diplomat Training

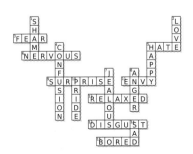

Biology 101

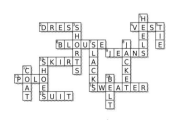

Emotional Train Wreck

Are You Smarter than a 5th Grader?

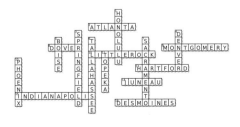

Crosswords: The Fashionista Edition

Are You a Renaissance Man... or Woman?

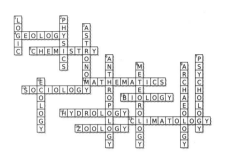

Diplomat Training Revisited

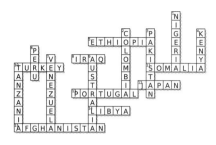

Astronomy Course: Stephen Hawking Difficulty

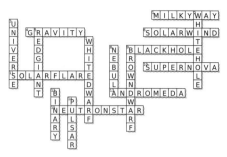

Insect Aficionado

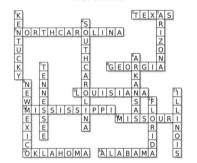

Mother Nature Has a Mean Temper

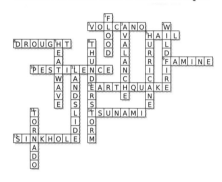

Crossword March Madness: The Final Chapter

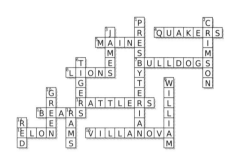

American Geography Extravaganza Revisited

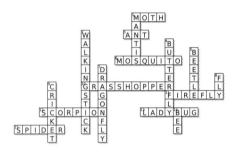

"I'll Be Back"

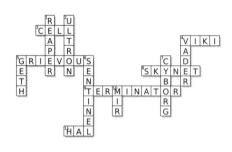

Diplomat Training: Secretary of State Difficulty

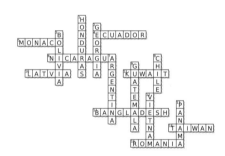

American Geography Extravaganza Finale

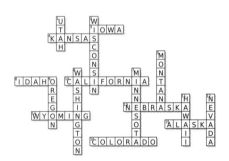

"It's Not Easy Being Cheesy"

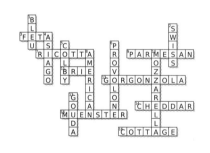

Laissez-Faire

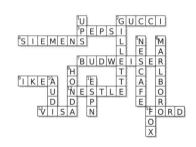

Math Nerds Unite!

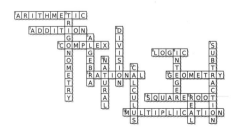

Forbes Picks

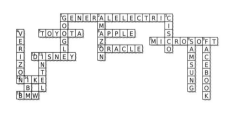

MLB Madness

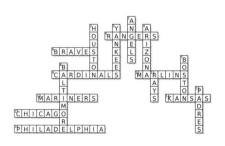